A Squeeze of Lime

To Maude
Happy Mom's Day
Love Kelly
2002

A Squeeze of
Lime

Linda Seigel Peterson

drawings by Linda Ryan

FITHIAN PRESS, SANTA BARBARA, CALIFORNIA · 2000

Cover illustration by Linda Ryan

Published by Fithian Press
A division of Daniel and Daniel, Publishers, Inc.
Post Office Box 1525
Santa Barbara, CA 93102
www.danielpublishing.com

LIBRARY OF CONGRESS CATALOGING-IN-PUBLICATION DATA
Peterson, Linda.
 A squeeze of lime / by Linda Peterson.
 p. cm.
 ISBN 1-56474-337-3 (pbk. : acid-free paper)
 1. Cookery (Limes) I. Title
 TX813.L55 P48 2000
 641.6'4337—dc21 99-050929

To my husband, Pete, with love and heartfelt gratitude

To my daughter Jennifer, with love and admiration

ACKNOWLEDGMENTS

Heartfelt thanks go to my husband, Pete, who steadfastly tasted, typed, edited, listened, loved, and encouraged me when I was ready to give up. And to my daughter, Jennifer, who inherited the cooking genes in the family and cheered me, encouraged me, and quietly asked, "How is your book coming, Mom?"

I would also like to thank the Santa Barbara Botanic Garden for the use of their extensive library, and Laurie Hannah for helping me research the book and for dong a little tasting and a lot of encouraging. Thanks to Bruce Van Dyke for taking time from his busy schedule to advise, write "The History of the Lime" for this book, taste, and tickle me with his humor; to Ben Faber and Nick Sakovich, both farm advisors for the University of California extension, for their expertise and advice on our orchard's production and quality of fruit; and to Elisa and Carlton LePine, who helped me taste and correct my recipes and answer my food phone calls.

Special thanks to my sister, Sheri Santillan; sister-in-law, Caryl Bornhoeft; and friends, Merle Barkan, Mike and Marian Kauffman, Mike and Alicia Kahle, and Sharon and Jerry Campbell, who tasted, tested, read and said the kind words "when, not if, you finish your book." And to Lynne LeCouvre, who advised me on writing specifics, and to my friend Sue Mills, who coined the phrase "Citrus is intoxicating," and who taught me the true meaning of courage (and the importance of never giving up) by winning her battle with cancer.

Thank you to Linda Ryan for the beauty of her artwork and the sweet sense of patience and dedication to *A Squeeze of Lime*. And a great big thanks to Susan Daniel for her editorial assistance.

Finally, thanks to friends and family who believed in *A Squeeze of Lime* and submitted their recipes to be used in this book.

Contents

Introduction
13

Beverages
25

Appetizers, Hors d'Oeuvres,
Dips and Spreads
37

Soups
51

Salads
61

Vegetables
77

The Entrée
89

Marinades, Sauces,
and Salsas
137

Desserts
151

Family Favorites
169

Index
207

A Squeeze of Lime

Introduction: A Passion for Cooking

"She that is of heart hath a continual feast."

—*Anonymous*

HAVE you ever heard anyone say, "I think I'll have a lime?" No, just too sour! The beauty of the lime is that it is a companion fruit—a fruit that enhances the flavors of vegetables, other fruits, meats, beverages, and desserts.

The lime is a special fruit that is available year round. Here in our little microclimate, the trees have a full cycle, from flower to mature fruit on a tree at any given time. The lime flower is very delicate with colors from pure white to cream, pink, and mauve. The fragrance of the flower is intoxicatingly crisp and clean. The perfect looking lime has bright green, slick skin. Yellow limes are juicier and sweeter, and make good marinades and drinks.

When I moved to La Collina Verde, which means "The Little Green Hill" in Italian, I was surrounded by a beautiful orchard with 700 lime trees on the hillside above Santa Barbara. Sharing limes with family and friends always presented the question, "Thanks, but what do I do with limes?" Experimenting with lime recipes was a hobby that has become a passion.

I love to cook. Cooking is not a hobby—for me, cooking is a passion. My great-grandfather Hanselman was a chef at the famous Broadmoor Hotel in Colorado Springs, Colorado. My Ganny (Grandmother) cooked what I call "soul food" from Arkansas. My mother was a fine cook who specialized in salads and gravies, and my father was an enthusiastic cook who experimented with seasonings—he cooked everything with garlic and gusto. My husband is the organized, excellent cook who makes gravy just as tasty as my mother's. And the passion has been passed on to my daughter, who is a "seat of the pants" cook who rarely uses a cookbook and always turns out wonderful food.

Burbank, California, was a wonderful place to grow up. When I was a child, coming home to the aroma of fresh baking bread and vegetable soup gave me a feeling of security, love, and well-being. This experience said to me, "Everything is good," and it was. Mother was home and smiling, my sister was home, and Dad would be home soon. To this day the aroma of "home cooking" brings back all those wholesome feelings.

The family table was probably the main place where our family dynamics subtly emerged. Mealtime was an important part of being together. The table was set and the *tone* was set. Whether this was payday or lean pickings, whether my parents were cheerful or cranky, even when the family felt stressed, we sat together at dinner and shared our day. We came together as a family—everyone had done his or her part to help, and it was time to sit and enjoy the meal together. And this time together was something to look forward to every day, even if, after dinner, there were the normal sibling squabbles with my sis, and facing the fact that, "Yes, this mess still had to be cleaned up."

Holidays brought an unbelievable amount of excitement to our home. The preparations began: everyone had a job, and everyone was busy and involved. There were special dishes—the apple pattern at Thanksgiving, the Spode Christmas pattern at Christmas, blue onion at Easter. The silver was polished, the linens were washed and ironed, the table was set in a festive way with flowers. At Thanksgiving in the 1940s, well over twenty relatives sat down to dinner together. After Aunt Louise's pie, we sat around the table and recorded everyone's feelings about the feast. My Uncle Bill said, "the dinner was real nice, Betty, but the turkey was a little dry." Some folks laughed, some gasped, as that crotchety, old voice critiqued the meal. My mother's face looked shocked…and then she laughed—what a sport.

In beautiful downtown Burbank (and it was to me), I took a Home Economics class at Jordan Junior High. Mrs. Koerner, a lovely lady from the Midwest with a peaches and cream complexion, taught us everything about a kitchen and how to cook. We were divided into groups of four, all working in one completely furnished kitchen. We learned the name and use of each utensil. We learned about cleanliness, food preparation, menu planning, timing, food presentation, even the order in which to wash dishes. All my kitchens have been arranged just like that kitchen in junior high, and when I wash dishes, the order is always the same—glassware, silver, plates, serving bowls, and pots and pans.

There were, and are, so many excellent cooks surrounding me, that rather than mentioning each one now, I'll tell you a little about each one with the recipes throughout the book. Having great cooks as role models, and experiencing such joy in cooking, I decided to write this book about cooking with limes as a way to share what I love to do.

Many of the recipes in this book were given to me by friends, starting back in 1987. I know that family and friends will be grateful that *A Squeeze of Lime* is finally complete. We have a joke around La Collina

Verde that people have offered to bring dishes for meals because they have tested and tasted so many lime recipes that they are afraid their lips will remain in a constant pucker. I would like to thank all of you who, out of courtesy, stopped asking when I would finish because it never seemed to end. When I read that my hero, Julia Child, spent ten years on her first book, I realized that I was in good company.

The limes from La Collina Verde have won first and second prizes at the Santa Barbara Fair and Expo and the Santa Barbara County Fair. Our limes have traveled to San Francisco, Los Angeles, Chicago, Hawaii, and New Zealand. I am lucky to be able to go out into the orchard, pick beautiful green limes, cut them open, squeeze the juice into a mixture of foods, and experience a taste like no other—fresh, clean, pungent, delicious. As I experimented with lime recipes, I enjoyed learning the idiosyncrasies of using the lime in cooking and around the house—too much lime in a recipe cannot be corrected, and subtlety is the word to remember; the flowers make a lovely garnish, but pluck carefully with tweezers; the juice is useful for cleaning around the house and kitchen.

The kitchen of La Collina Verde is the heart of our home. We entertain in a relaxed country style, and it is not unusual for guests to string beans, toss a salad, cut flowers for the table, check the grill, or do the dishes. Everyone is welcome to participate. The bunkhouse invites overnight guests for short stays, some of which have extended to a month or more. Many a guest has prepared a specialty for Pete and me. Many lime recipes have been created in the kitchen while cooking with family and friends, tasted, and tasted again until the recipe is just right. God willing, many new lime recipes will come to life this same way for decades to come.

History of the Lime

The sour orange and lemon were introduced into Persia, Syria, Palestine and Egypt from India sometime during the early or mid tenth century A.D. by the Arabs. The lime was soon to follow. As the Crusaders returned from their wars in the Near East they brought back many unusual and interesting plants that included the limes. By the thirteenth century the area of Liguria, a crescent of Italy that borders the Mediterranean Sea with the western end at the French border and Genoa at its center, had well established citrus plantings.

Limes were brought to the Americas by the Spanish and Portuguese explorers during the early part of the sixteenth century. Some of the limes that were planted in the West Indies and southern Florida escaped cultivation and their progeny may be found spontaneously growing as scattered plants or thickets. Subsequently, much of this industry was decimated by hurricanes and freezes. Limes came into such great demand by the British navy to prevent scurvy that the sailors were referred to as "limeys."

In the gold mining camps of California in the 1850s, settlers paid handsomely for limes that were imported from Tahiti and Mexico. To meet the demand, limes were even shipped from Italy. This spurred citrus planting in southern California, and in the 1870s and early 1880s, the acreage of limes exceeded that of lemons. When it was found that lemons could be picked green and held for months under cool conditions before being sent to market this fruit became more profitable.

Limes (*Citrus aurantifolia*) fall into four groups. The Mexican lime is the true species as it seeds itself and grows true to form. It produces a small tree that is bushy with fine branches, numerous thorns, and small leaves. The fruit of the Mexican lime is small and has many seeds. They are the least hardy of the limes.

The Tahiti lime is a group that originated in Tahiti and is thought to be a hybrid between the Mexican lime and the lemon. The tree is much larger than the other species—the leaves are larger, the branches are coarse, and it is semi-thornless to thornless. The large fruit of the Tahiti lime group is seedless, an indication that it is a hybrid.

The Mandarin lime group is much more like a sour Mandarin than a lime. The most common variety of this group is the Rangpur lime, which resembles the common tangerine. It is very cold hardy and may be used as an ornamental—and the fruit will be mistaken for a tanger-

ine only once by the unfortunate sampler. This highly acid fruit is called a lime, so it won't be confused with the more marketable tangerines.

The fourth group is the Sweet lime group that seems to be a form of Tahitian lime or a hybrid of lime and citron. The almost complete lack of acid relegates it to botanic collections in the United States, but it is much prized in Egypt, Mexico, and South America.

The Bearrs lime, the lime grown at La Collina Verde, is a member of the Tahiti lime group that originated about 1895 on the place of T.J. Bearrs at Porterville, California. Mr. Bearrs, a Southern Pacific stationmaster, was both an experimenter and nurseryman, who probably grew this variety from a selected seedling grown from Tahiti seed. The Bearrs lime has several features that make it superior to other members of the Tahiti group. The fruit has a high acid content, is richer in flavor, and it is seedless. The Bearrs lime well deserves to be the variety with the largest planting in California.

—Bruce Van Dyke

Bruce Van Dyke is Santa Barbara's resident authority on all matters green and growing. Shortly after World War II he graduated from UCLA with a degree in horticulture. In the years since he has been a horticulturist for Ganna Walska at her world-renown garden, "Lotusland," and has consulted with the city and the city arborist about the trees on our beautiful tree-lined streets. He also taught a gardening course for thirty-five years for Santa Barbara City College's adult education program, and wrote a weekly column for the Santa Barbara News-Press *for thirty years. Bruce was instrumental in founding the Master Gardener Program sponsored by the Santa Barbara Botanic Garden and the University of California Cooperative Extension. He serves on many boards of directors, is an honorary member of The Little Garden Club, a keen advisor, and a wonderful friend.*

Mr. Van Dyke's primary source for this essay was The Citrus Industry, Volume I, History, Botany and Breeding, *University of California Press, 1946.*

Creative Leftovers

There are foods like stew and chili that are best the next day, and the following day, until the pot is literally licked clean. These are the traditional leftovers that would be almost sacrilegious to change. Creative leftovers is based on the concept of planning many meals using and combining dishes already prepared.

Some of our favorite meals are based on this concept, and perhaps the best example is salmon (a whole salmon with the head removed). We intentionally start with a large salmon—4 to 6 pounds—and cook it as described in the recipe for Salmon La Collina Verde.

The first meal is Salmon La Collina Verde, Fettuccini Alfredo (prepare at least twice as much as you need for this meal), and steamed broccoli (again, prepare at least twice as much as needed). After the meal, we cut up the leftover broccoli and part of the salmon and add to the pasta bowl, cover, and refrigerate it.

The next day we take the pasta bowl from the refrigerator and make La Collina Verde Pasta Salad for dinner.

There will be more leftover salmon, which can be frozen and used for scrambled eggs and onions (sautéed) with salmon; egg salad and salmon, which is especially good with avocado; Salmon Benedict with Lime Hollandaise Sauce; Simple Green Salad or Spinach Salad with salmon.

If you have a family of four, it is easy to see how many meals can be served using the salmon. And, besides being less expensive than salmon steaks, the tail, when prepared as directed, is moist, has better flavor, and more versatility.

We use this basic approach for a number of other meals:

Chicken or turkey—both oven roasted and cooked on the Weber barbecue grill

Roast pork—either oven roasted or grilled

Roast lamb—especially grilled

Roast beef—especially tri tip, grilled

Broiled tuna—we use thick 1½ inch Ahi steaks

Pete's squid—especially for two meals

When we use a Weber grill, we use the 22-inch kettle and cook roasts using the indirect method described in the owner's manual. We use a meat thermometer to test for the desired degree of doneness.

Bachelor Cooking

In a lifetime, most people go through times when they live alone, and like everything there is a right way and a wrong way. I have spent many years as a bachelor, and being blessed with low cholesterol, a wild metabolism, and a huge appetite, I figured out early on that I had best learn to cook for myself. Most of the food I cooked during my bachelor periods was hearty, not very complicated, and not too difficult if a little planning was done. I consider this the right way. I am also a snob and almost never eat fast food or junk food, both of which I consider the wrong way.

One of the few advantages male bachelors have is that they probably haven't learned most of the traditions of cooking passed along the female line and can start with few preconceptions. For example, here's a story I heard years ago. A young couple were having their family over for their first Thanksgiving dinner. As they prepared the turkey, the wife cut a little piece off the end. When her husband asked her why she cut the end off the turkey, she replied that her mom always did that. When Mom arrived, he asked her why she cut the end off the turkey, and she replied that Grandma always did. When Grandma arrived, he asked her, and she said that when she was first married she didn't have a roasting pan long enough for the turkey and got in the habit—tradition. However, I did learn to make sauerbraten from my mother, and she taught me two ways to make gravy, all of which I'm grateful for.

In my years in the Air Force and later, I knew many men who were single, long past the norm. Most of them were decent cooks, and almost all of them had a specialty that was extraordinary.

Probably the biggest problem learning to cook is how to figure the timing of a meal. I think the simplest way is to decide what time you want to eat and count backwards, figuring how long the various parts of the meal will take to prepare and cook. Now you know when to start each dish. I realize that it isn't politically correct, but I would start the meal by building a scotch and water or a beer to help with the timing. As I have grown older, I hardly do this anymore—then again my timing is now a little better.

For example, if you are going to barbecue, it takes forty-five minutes to an hour for the fire to be ready. These days I use a chimney to start the charcoal. It only takes one and a half pages of newspaper and a match. I use a 22-inch Weber kettle barbecue almost exclusively, and I'm learning to use the indirect method (with the coals divided on the

sides, a drip pan in the middle, and the lid on) more and more. This method imparts a semi-smoked flavor and the fire doesn't flare up. I believe the coals make a hotter fire than an average oven setting, and things cook a little quicker. I am also convinced that the kettle shape is probably the most efficient shape for an oven because the heat comes evenly from all directions. I only use the direct method of cooking foods over the coals when the cooking time is less than half an hour. The Weber booklet is a good guide for cooking both ways.

The single best source for directions on how long to cook meat, fowl, or fish is your butcher, and it is amazing how much help they will give a bachelor. Years ago, I was talking to the local butcher and thanked him for the care he took in assuring I got the cut of meat I wanted (even if I didn't know what I wanted). He replied that it was generally the wife who knew how to cook and he liked to look out for single guys.

Once you decide it is time to start, prep (wash, chop, slice, grate…) the various ingredients and get everything ready to go. If you are cooking a roast, that will be the first thing to start cooking. Sometimes I would cook a whole roast just for myself and freeze "TV dinners" with what I wanted. If you are broiling or frying a steak, a chop, or piece of chicken, the vegetables and meat start at about the same time.

Pasta and potatoes take about twenty-five to thirty minutes to cook, mainly because there is a large quantity of water to heat. Most vegetables take about twenty minutes. The simplest way to cook them is to steam them, and test with a fork until they are done to your liking.

While the cooking is taking place, there is time to make a salad. In those days I used bottled salad dressing because I didn't know about Linda's Lime Vinaigrette dressing. Now I make a big batch of this dressing, leaving out the Parmesan and Gorgonzola cheeses, and use it as needed, adding the cheeses when I make the salad.

For most of my bachelor years I didn't have a dishwasher (in those days I figured an automatic ice-maker was far more important) and got in the habit of filling the sink with hot, soapy water. When a pan was emptied I would rinse and wash it and put it in the rack to dry. This way, when I finished dinner, the only things to wash were my plate and silverware, and the water would still be hot enough to wash these—and the clean-up was finished.

We all have some idiosyncrasies, and here are some of mine:

For eggs, I preheat a cast-iron frying pan (to season the pan ask your

butcher for some suet to fry slowly in it), fry the eggs in a little butter, and clean out the pan by wiping it well with paper towels. If you wash it with soap it has to be reseasoned.

Seasoning is an individual preference. Primarily I use Lawry's Seasoned Salt, plain salt, and fresh ground pepper. I read that herb and spice measurements in recipes are imprecise, which freed me to approximate—I didn't have measuring spoons anyway. I use seasoned salt on meats, fried potatoes, and cabbage, and paprika in white sauce to give it a little color.

If you like mashed potatoes occasionally, Idaho potato flakes are very good and don't grow leaves and roots in your cupboard.

Finally, I would like to share something I learned from a friend who is a professional chef about how to tell when meat is done. Here is:

Carlton's Rule of Thumb

Touch your thumb to your little finger gently and feel the fleshy, bottom part of your thumb with the thumb and index finger of the other hand—this is well done.

Do the same thing with the thumb and ring finger—this is medium.

Do the same thing with the thumb and middle finger—this is medium rare.

Do the same thing with your thumb and index finger—this is rare.

Actually, this is a pretty good guide, and if you use a meat thermometer on a roast, you won't be too far off.

Remember, don't be intimidated!

—Pete Peterson

Limelights

"I dieted for two weeks and all I lost was the two weeks."

—*Totie Fields*

Lime is a companion fruit that enhances flavor—

A squeeze of lime perks up the taste of food, keeps fruits from turning dark, is great for flavoring foods while watching calories, and is a healthy way of eliminating salt without diminishing the flavors of food. Try a squeeze of lime with the following foods and enjoy.

Wash ripe papaya, cut in half and remove the seeds. Serve with a quarter of a lime.

Wash cantaloupe or honeydew melon, cut in half or quarters, and remove seeds. Serve with half a lime.

Wash an avocado, cut in half, and remove seed. Serve with half a lime.

A squeeze of lime on apples, avocados, pears, bananas, and kiwis keeps the fruit from turning brown and perks up the flavor. The juice of a lime squeezed over a fruit salad enhances flavors.

A squeeze of lime brings the flavors of a fresh green salad together using only seasoning herbs and spices. You can forget high-calorie dressing.

No chicken soup when you catch a cold? Squeeze the juice of 2 limes in a cup of boiling water, add 2 tablespoons of fresh chopped parsley and 2 cloves finely chopped garlic. Steep 2 minutes.

A squeeze of lime in mineral water over ice makes a refreshing drink with zero calories.

A squeeze of lime with Coke, Pepsi, cranberry juice, or V-8 adds a zippy taste to these non-alcoholic beverages.

Limebrights

Using lime for household uses will brighten up your day—

Use fresh lime to remove the odor on your fingers when chopping garlic.

Use ½ or ¼ of a lime to clean and remove heavy odors from chopping knives.

Squeeze a lime on the bottom of a copper pot and sprinkle salt over the lime juice. Scrub the copper with a porous sponge and *voilà*, sparkling clean using no chemicals.

A squeeze of lime in the dishwater will cut grease.

A squeeze of lime on kitchen counters will remove excess grease or food residue while freshening up the counters. Rinse with warm water.

A squeeze of lime will remove odor from cutting boards.

A squeeze of lime will freshen toilet bowls.

Squeeze lime on tile grout. Let sit for a couple of minutes and scrub grout with a stiff brush. Rinse well.

Use cut up limes to deodorize the garbage disposal.

Beverages

May your glass be ever full.
May the roof over your head be always strong.
And may you be in heaven half an hour before the devil knows you're dead.

—Irish toast

E IGHT glasses of water a day is recommended by health professionals. Once that requirement has been met throughout the day, beverages of all sorts—libations, cocktails, spirits, drinks, whatever you call your thirst-quenchers—will be enhanced by a squeeze of lime, as will the water you drink.

Centuries ago, lime was prescribed by sea captains to prevent scurvy (a disease caused by vitamin C deficiency), and each sailor had one lime a day—thus the term "limey." In the past, the lime was often called the "bar lime." Most photographs of lime, until quite recently, have shown limes floating in tall cocktails. So, lime-enhanced liquid refreshment of all sorts has been part of our culture for a long time.

Plain old H_2O comes alive with a squeeze of lime. That refreshing taste of water with a squeeze of lime is healthy, makes drinking those eight glasses a day easier, and is good for the digestion. Try a squeeze of lime (as mentioned in "Limelights") in cold or hot tea, vegetable juices, or carbonated drinks.

Lime is especially fine in many cocktails. Try the Orchard Cooler, one of La Collina Verde's favorites, with fresh-squeezed orange juice, lime juice, rum, triple sec, and crushed ice. Play around with the recipes in this chapter—sometimes a blender adds that special frothy taste. Then again, you might want to keep it simple with that old standby, the Martini—vodka on the rocks with a twist of lime. Any of the alcoholic drinks in this chapter can be made "virgin" by omitting the alcohol.

Whatever your choice of thirst-quencher, try a squeeze of lime. So, here's to your health! Cheers! Cheerio! *Skoal!* *Salut!* *Prosit!* *L'chayim!* *Mazel tov!* Happy days! Good Luck! Here's looking at you, kid! Here's mud in your eye! Bottoms up! Down the hatch! Whatever your favorite is, any time is lime time for you.

Mixed Drinks

For each of these drinks use a cocktail tumbler filled with 4–5 ice cubes. Add the ingredients, stir, and enjoy!

La Collina Verde Martini

1 jigger of Tanqueray or the gin of your choice
A squeeze of lime
Water to fill glass
2 garlic-stuffed olives

LCV Vodka Cocktail

1 jigger Absolut or the vodka of your choice
A squeeze of lime
Water to fill glass
2 Cajun-stuffed olives

Scotch Cocktail

1 jigger Johnny Walker Black or the scotch of your
 choice
Lime twist (rub the lime twist around rim of glass
 and add to glass)
Water to fill glass

Sweet Vermouth Cocktail

½ glass sweet vermouth
A squeeze of lime
Club soda to fill glass

The Peg

To a 12-ounce glass with 4–5 ice cubes add:
 1 jigger brandy or rum
 A squeeze of lime
 Sparkling mineral water to fill glass

Orchard Cooler

To a 12-ounce glass with 4–5 ice cubes add:
 Juice of 1 orange
 Juice of ½ yellow lime (sometimes sweeter and
 juicier)
 ½ ounce Triple Sec
 2 ounces Bacardi Gold

Fill to ½ inch of rim with sparkling mineral water. Garnish with a slice of orange.

Island Breeze

To a 12-ounce glass with 4–5 ice cubes add:
 Juice of 1 tangerine
 Squeeze of lime
 Splash of Triple Sec
 1½ ounces of Bacardi Gold

Fill to ½ inch of rim with sparkling mineral water. Garnish with a slice of tangerine.

Cool Breeze

To a 12-ounce glass with 4–5 ice cubes add:
 1½ ounces of Bacardi Gold
 Squeeze of lime

Fill to ½ inch of rim with sparkling mineral water. Garnish with a slice of lime.

Bloody Mary

 1 jigger vodka
 4–5 ice cubes
 8 ounces of V-8 juice
 1 lime
 Tabasco sauce
 Worcestershire sauce
 Seasoned salt
 Fresh ground pepper
 1 stalk celery or 1 green onion

Dip rim of a tall chilled glass in seasoned salt. Add ice cubes and vodka. Pour in V-8 juice. Squeeze ½ the lime into drink. Add dash of Tabasco sauce, Worcestershire sauce, and seasoned salt. Garnish with celery or onion and remaining ½ lime.

Cubra Libre

 1 jigger rum
 Juice of ½ lime
 4–5 ice cubes
 1 Coke

To a tall tumbler add the ice, rum, and Coke. Squeeze ½ of lime into drink and garnish with lime wedge.

Pimm's Cup

1 jigger Pimm's Cup
4–5 ice cubes
About 8 ounces of club soda
1 lime
1 stalk celery

To a cocktail tumbler add the ice, Pimm's Cup and soda. Squeeze juice of ½ of lime into drink. Garnish with celery stalk and ½ a lime.

Beer Mary

1 Firestone Ale or beer of your choice
4 ounces V-8 juice
1 medium lime
1 iced glass
Celery salt to coat rim of glass
Seasoned salt
Fresh ground pepper
1 dash Tabasco sauce
1 dash Worchestershire sauce
1 celery stick

Dip rim of chilled glass in celery salt. Add 4–5 ice cubes. Pour beer into glass. Shake V-8 and add to beer. Squeeze lime into the drink. Add seasoning, stir, and garnish with celery stick.

Corona and Lime

1 Corona
1 lime wedge
1 glass

Tecate and Lime

1 Tecate
1 lime wedge
Salt
1 glass

Sparkling Limeade Mist

6 large limes
½ cup sugar
1 liter of sparkling water
Ice
Lime slices and mint sprigs

Put about 6 ice cubes in pitcher.
Pour sugar over cubes.
Squeeze limes over sugar and ice cubes.
Pour sparkling water in pitcher.
Garnish with lime slices and sprigs of mint.

Kai Poroche

This recipe was given to me by my dear friend and counselor Lynn Cantlay. Lynn taught me logic, the joy of being normal, and what friendship and laughter are all about. I am grateful to Lynn for what she taught me and how she taught me with such kindness.

Chill cocktail tumblers.
Put 4–5 ice cubes in each glass.
Squeeze juice of 1 medium lime in each glass.
Add ¼ teaspoon sugar.
Pour 1 jigger of vodka in each glass.
Stir and serve with a wedge of lime.

Margaritas

This recipe was given to me by Raoul Figueroa. Raoul is one of those people who makes everything a pleasure—even work. He loves to barbecue, and when he describes a recipe your mouth begins to water.

1 shot tequila
1 shot triple sec or Cointreau (or other orange
 liqueur)
1 shot lime juice
1 shot water mixed with a little sugar.

Rub a glass with the used lime rind and dip in salt to taste.
Fill glass 25–30% with crushed ice.
Add all ingredients and mix gently.
Add more tequila to taste.
For strawberry margaritas, add 3–4 crushed strawberries.

Marian and Mike's Margaritas

I was, I thought, finished with A Squeeze of Lime when Marian and Mike suggested we come for a small fiesta and testing of a new margarita recipe—on the condition that we bring the limes. Spending the evening in the Kauffman's beautiful home, sipping margaritas, and eating chimichangas was great fun.

½ cup frozen lime juice
1 cup tequila
2 cups crushed ice cubes
1 cup beer

Mix in blender and serve in chilled margarita glasses with thin slices of lime.

Amy's Mai Tai

This is by far the best Mai Tai—mixed by Amy and taught to Pete and me—I've ever had. Sitting at the bar at the Kona Inn in Kona, we ordered Mai Tais, tasted them, and asked the bartender, who was very busy at the time, if we could have her recipe because we were just finishing our lime cookbook and would love to include her wonderful Mai Tai. Can you imagine how many stories Amy has heard at the Kona Inn bar? She was skeptical at the time but still walked us through the process, making the perfect Mai Tai every step of the way.

Juice mix for two drinks:
½ cup orange juice
½ cup pineapple juice

Put ice to ½-inch of the rim of two tumblers.

To each add:
Splash of Grenadine
½ jigger Bacardi Silver
Juice mix to 1 inch from the top of glass
Splash orgeat syrup

Splash Curacao or other orange liqueur
½ jigger Bacardi 151
Squeeze of lime

Mix and float dark rum over top (Amy's favorite is Diamond Head, but you can substitute Myer's, Lemonhart, or Whalers Dark). Garnish with a wedge of fresh pineapple.

Sangria by Sue

This was Sue Mills's contribution to a barbecue we had during the summer. She suggested making Sangria, which I had never tasted. Sue went into the orchard, harvested the fruit, and made this refreshing punch.

1 orange, juiced
½ lemon, juiced
1 lime, juiced
1 lime, sliced thin for garnish
2 cups hearty Burgundy
2 cups sparkling mineral water
⅛ teaspoon sugar
Crushed ice

Pour juice of citrus into a clear serving pitcher.
Add crushed ice.
Add Burgundy.
Add sparkling mineral water.
Add sugar.
Mix well and garnish with lime slices.
Served in chilled glasses.

Appetizers, Hors d'Oeuvres, Dips and Spreads

"Cheese—milk's leap toward immortality."

—*Clifton Fadiman,* Any Number Can Play *(1957)*

SETTING out the appetizers, hors d'oeuvres, dips, and spreads is my favorite part of preparing a special meal. Guests have been invited to share the meal, the meal has been planned, food prep is done as much as possible, and the table has been set.

The tone is set for the guests. Whether the meal is casual—a buffet or barbecue—or elegant, the welcome mat is out. Welcoming your guests by being prepared for them feels warm and cozy, and that is where the appetizers come in. Keeping it simple and easy for everyone to manage the food helps the social hour or cocktail hour flow easily with good conversation, laughter, and relaxation until mealtime.

At the homes where I have most enjoyed being a guest, the host or hostess always seems organized and comfortable. I checked with some of these hosts and found they felt that organization is the most important part of entertaining. Working with some of Pete's ideas about planning, I found that if I do the dessert first, then the appetizers—often cheese, fruit, and crackers—then the rest of the meal falls into place.

It seems that the art of entertaining is changing, and most people like to meet in restaurants. The art of entertaining at home is truly an art because it does take work and planning. When guests are laughing and talking and enjoying the hors d'oeuvres, for me there is the happy anticipation of the forthcoming meal and a successful get-together.

Artichoke Tapenade

1 15-ounce can of artichoke hearts, drained and
 chopped
2 ounces capers, drained
1 clove garlic, chopped
¼ cup extra virgin olive oil
1 tablespoon red wine vinegar
¼ teaspoon each seasoned salt and garlic salt
Fresh ground pepper
1 lime
Crackers—we like Triscuits

Mix all ingredients together and squeeze lime over mixture. Mix well. Best if marinated at least 4 hours.

Serve with crackers.

I like to accompany this dip with Gouda or Cambazola cheese.

Herb and Lime Cheese Ball

2 8-ounce packages cream cheese, softened
1 cup Gorgonzola cheese
1 cup shredded sharp cheddar cheese
3 tablespoons Worcestershire sauce
Juice of 2 large limes
2 teaspoons each fresh thyme, basil, and parsley
1 teaspoon fresh ground pepper
1 teaspoon each seasoned salt and garlic salt
Pine nuts or sunflower seeds

Soften cheeses. Add all ingredients and mix together.
Shape into a ball and wrap in plastic wrap.
Chill overnight.
Roll in pine nuts or sunflower seeds before serving.
Serve on a platter with cocktail rounds or crackers.
Garnish platter with herbs and lime slices.
Makes 2 cheese balls.

This makes a great gift for the holidays.

Crab Dip

½ pound fresh crab meat
1 8-ounce package cream cheese
½ cup sour cream
2 tablespoons mayonnaise
Juice of 1 medium lime
2 teaspoons Worcestershire sauce
3 dashes Tabasco sauce
½ teaspoon garlic powder and seasoned salt
½ teaspoon fresh ground pepper
1 cup cheddar cheese
Parsley and lime slices for garnish

Preheat oven to 350 degrees.

Combine all the ingredients except ½ cup of cheddar cheese in a small baking dish.

Sprinkle with remaining ½ cup cheddar cheese.

Bake at 350 degrees for 30 minutes.

Garnish with lime slices and parsley.

Or serve as a stuffing for mushrooms.

Bake 30 minutes.

This dip can also be served without cooking. Spread on celery halves or crackers.

Shrimp Cocktail

4 large shrimp per person, cleaned, cooked, and
 chilled
Red leaf lettuce, washed and crisped
1 ripe avocado, cubed
4 celery stalks, chopped
1 lime
Cocktail sauce
Wedges of lime

Place torn lettuce leaves in the bottom of 4 chilled martini glasses.
Add avocado and celery which have been mixed together.
Squeeze lime over all.
Top with ¼ cup cocktail sauce.
Put 4 shrimp on the lip of each glass.
Garnish with a wedge of lime.
Serve with lavosh crackers and chilled cocktail forks.

Sautéed Bay Scallops
with Lime and Herbs

1 pound bay scallops
2 cloves of garlic, minced
1 medium lime
1 tablespoon each fresh parsley, lime thyme, and
 oregano, chopped
1 tablespoon butter
1 tablespoon olive oil

Sauté garlic and herbs in olive oil and butter until just golden.
Add scallops and sauté for 6–8 minutes.
Squeeze lime juice over ingredients.
Remove with a slotted spoon and put on a small plate.
Serve with cocktail sauce and cocktail forks or colored toothpicks.
Garnish with thin slices of lime and herbs.

Lime and Herb Oysters

1 6-ounce bottle shucked raw oysters and ½ the juice
Juice of 1 medium lime
1 tablespoon each fresh rosemary, oregano, thyme
 and parsley, chopped fine
½ cup Parmesan cheese
Dash of Tabasco sauce, seasoned salt, and fresh
 ground pepper, or to taste
4 baking shells or cups

Preheat oven to 350 degrees.
In a bowl mix the oyster juice with the lime juice.
Add herbs, Tabasco sauce, salt, and pepper and mix well.
Place 4–6 oysters in each shell.
Pour a quarter of the mixture over oysters and sprinkle with
cheese.
Bake for 10 minutes.
Serve with crackers and cocktail forks.

Guacamole

4 ripe avocados
2 limes
1 large tomato, chopped
2 cloves of garlic, minced
2 tablespoons fresh cilantro, chopped
½ teaspoon seasoned salt
Dash salt
Generous amount of fresh ground pepper
2 dashes Tabasco sauce

Peel and mash avocados.
Immediately squeeze limes over mashed avocado, both for flavor
and to keep it from turning dark.
Add chopped tomato and garlic.
Add seasoned salt, salt, pepper, and Tabasco sauce.
Mix well.
Garnish with fresh chopped cilantro and serve with tortilla chips.

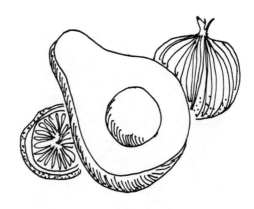

Laurie's Salsa

Laurie Hannah has been a guiding light throughout the writing of this book. She is the librarian at the Santa Barbara Botanic Garden and was helpful in guiding me to the extensive resources available in the garden's library. Every time I was discouraged about the enormity of this project she would come up with a recipe or idea for the book that would spur me on. Thank you, Laurie, for giving me the morale boosters and for coming to dinner and tasting many of these lime recipes.

1 15-ounce can black beans, drained
1 15-ounce can pinto beans, drained
1 15-ounce can corn
½ medium red onion, finely chopped
1 8-ounce jar salsa
½ bunch cilantro, chopped
1 avocado, chopped
1 mango, chopped
Juice of 2 limes

Mix ingredients together and serve with tortilla chips.

Summer Bruchetta

It seems at the end of summer when most of the crops have been harvested, almost every gardener and supermarket has plenty of tomatoes and basil. This combination of herbs and fruit, along with good bread and cheese makes a tasty appetizer.

4 tomatoes (best if home grown), chopped in small
 pieces
2 large cloves garlic, chopped
Juice of ½ lime
½ cup fresh basil, chopped fine
5 ounces goat cheese
1 small baguette sourdough bread
Extra virgin olive oil

Slice baguette into ¼-inch slices.
Place tomatoes, garlic, lime juice, basil, and ¼ cup olive oil in a mixing bowl and mix well.
Brush olive oil on each slice.
Spread goat cheese on each slice.
Toast lightly.
Top toasted baguette slices with tomato mixture.
Enjoy!

Oven-Fried Chicken Drumettes

40 chicken drumettes (figure 4–5 per person)
5-ounce bottle soy sauce
Juice of 1 medium lime
⅓ cup ground ginger
2 tablespoons garlic powder
3 cups Wondra flour
Olive oil for cooking

Preheat oven to 350 degrees.

Marinate drumettes in lime juice and soy sauce overnight, turning them now and then.

Mix dry ingredients well and place in a large baggie.

Add drumettes to bag and shake well to coat.

Remove, shake off excess flour, and put on a plate.

Pour a small amount of olive oil in a Pyrex baking pan and add drumettes.

Bake for 30 minutes and turn.

Bake for 30 minutes more.

Drain on a paper towel and place in a warm oven until ready to serve.

Soups

Beautiful soup, so rich and green,
Waiting in a hot tureen!
Who for such dainties would not stoop?
Soup of the evening, beautiful soup!

—*Lewis Carroll,* Alice in Wonderland *(1865)*

M AKING soup is a special cooking experience. For me, making soup is a rewarding experience in a variety of ways. I turn on the symphony music, start a crackling fire in the fireplace, bring out a soup pot big enough to feed the Salvation Army, and the stage is set.

Something magical happens when you can transform water into a delicious healthy, nourishing meal or starter course. Each ingredient adds a new aroma to the broth. I remember coming home from school and being greeted by my mother. Fresh bread was baking in the oven while the savory soup filled the whole house with "home cooking" smells.

Maybe that is why I enjoy making soup and setting the atmosphere for cooking soup. A spiritual sense of well-being comes over me. If I'm blue I just feel better and the soup is tasty and reassuring in itself.

Soup is rewarding because you can accomplish a number of tasks: cooking ahead for a busy schedule, setting soup aside for friends and family, using up leftovers.

Soup is easy, a one-pot meal and quick clean-up. Soup can be a main course, the kind you want to dip your bread in, peasant style—or an epicurean delight to enhance the rest of your meal.

Everyone has their favorite soup. There are many wonderful soup recipes to experiment with. Whatever your choice, I hope you enjoy making soup as much as I do. My grandfather always used to say, "You can always tell a good cook or a good restaurant by their soup, and honey dear, yours is delicious."

Cream of Carrot Soup

My grandson, Jamari, and I made this soup together one day after school. He was only ten at the time, and carrot soup is not something the average child would enjoy, but Jamari has always been an exceptional child. We made the soup, and he suggested adding the lime. We also made Lime Vinaigrette Salad, and he made the dressing perfectly.

1½ cups carrots, sliced thin
¼ cup grated carrots
1 onion, chopped
1 clove garlic, minced
1 tablespoon fresh thyme, chopped
1 tablespoon fresh parsley, chopped
Juice of 1 medium lime
½ cube unsalted butter (4 tablespoons)
½ cup heavy cream
½ teaspoon fresh ground pepper
⅛ teaspoon regular salt
⅛ teaspoon seasoned salt
2 cups water

In a medium saucepan sauté onion and garlic and pepper in unsalted butter until lightly golden. Be careful not to scorch unsalted butter.

Add sliced carrots and stir for 3 minutes.

Add salts and stir briefly.

Add 2 cups warm water gradually and bring to a boil, stirring constantly.

Cover and cook on low heat for 15 minutes, stirring occasionally.

Add cream and blend.

Squeeze lime into soup and stir well.

Add grated carrots.

Serve piping hot.

Garnish with thin lime slices and herbs.

Serves 4 as a first course for dinner or a main course for lunch. It's also good served cold.

Marian's Leek and Potato Soup

Marian invited me to her home for a light lunch and to make wreaths made of succulent plants for Christmas gifts. She sent me a list of supplies required for the project along with a note about the time of arrival and the dress code—jeans, gardening gloves, and comfy shoes. We created our wreaths using succulent cuttings with a wide variety of colors, and the finished products were lovely. We washed our dirty hands, using a nail brush to scrub out the extra dirt, and sat down, jeans and all, to a table set with linens and fresh flowers, and enjoyed leek and potato soup and fresh bread.

3 leeks, chopped (white part only)
2 medium boiling potatoes, peeled and diced
1 tablespoon butter
4 cups water
Salt
Dash nutmeg
Chives, chopped
Juice of 1 small lime, optional

Sauté the leeks in butter in a medium saucepan.
Add potatoes and water and simmer until tender, 15–20 minutes.
Season with nutmeg and salt.
Pour into a blender or food processor and pureé.
Blend in the lime juice, if desired.
Serve sprinkled with chives.

Fish Soup with
Fennel, Leeks, and Lime

Nonstick cooking spray or 1 tablespoon olive oil
2 cups leeks (white part only), chopped
2 cups fennel bulb, chopped
2 cloves garlic, minced
2–2½ cups chicken broth
1 (8-ounce) bottle clam juice
1 pound halibut, cut into 4 pieces
Salt, fresh ground pepper
Dash of cayenne (optional)
Juice of 1 large lime
¼ cup each chopped fennel fronds and shredded
 carrot for garnish

Spray a 4-quart pot or deep frying pan with cooking spray (or add oil).

Sauté leeks, fennel, and garlic over medium heat until tender and limp, about 10 minutes.

Stir in chicken broth and clam juice and bring to a boil.

Reduce heat, cover, and simmer 10–20 minutes.

Add halibut and reduce heat to very low.

Cook, covered, for about 10 minutes.

Season with salt, pepper, cayenne and lime juice.

Spoon into serving bowls and sprinkle with a bit of chopped fennel and shredded carrot.

Serves 4 as a first course, 2 as a main course.

Chicken Soup

This is a hearty complete meal served with fresh bread and beverage. Sometimes when I'm feeling kind of punk, I slice extra garlic, onion, and fresh parsley and sprinkle over my serving. This soup is good with fresh Parmesan cheese grated over the top. Adding dumplings makes it more like a chicken stew. In the fall I triple the recipe and freeze it for friends and family, so Chicken Soup is all ready for cold and flu season and cold winter nights.

1 large chicken, whole or pieces, with giblets
4 quarts water
2 large onions, sliced
4–6 large cloves garlic, chopped
6 carrots, sliced
4 stalks celery, including tops, chopped
4 potatoes, sliced
½ pound green beans, snapped
4 medium zucchinis, sliced
1 head cabbage, sliced
½ teaspoon seasoned salt
Generous amount of fresh ground pepper
Dash salt
½ cup fresh parsley, stems removed
Juice of 1–2 large limes

Place washed chicken and water in a large soup pot and bring to a boil over medium heat, skimming froth off the top.
Cook chicken for about 40 minutes on medium low.
Set chicken on plate to cool.
Add garlic and onion to the broth and bring to a boil.
Turn heat to low and add all the vegetables except the cabbage.
While the soup simmers, clean chicken off the bone.
Simmer 20 minutes and add cabbage, chicken, and seasonings.
Simmer until vegetables are done.
Serve piping hot with a squeeze of lime and fresh parsley sprinkled in each bowl.

Lime Soup

1 3–4 pound chicken
6 cups water
1 onion, chopped
2 cloves of garlic, chopped
½ green pepper, seeded and chopped
1 tomato, chopped
Juice of 1 lime
Zest of 1 lime
Thin slices of lime
¼ cup of fresh cilantro, chopped
1–2 tablespoons corn oil
4 tortillas, sliced

Wash chicken and remove giblets.
Put chicken and giblets in large soup pot and add 6 cups of water.
Bring to a boil and cook on medium heat for 1 hour or until chicken comes loose from the bones.
Set chicken on a plate to cool.
Sauté onion, garlic, bell pepper, and tomato in corn oil.
Add vegetable mixture to the broth.
Squeeze juice of 1 lime into soup and add lime zest.
Bring soup to a boil and reduce heat to simmer for a few minutes.
Remove chicken from bones and add to soup.
Dice chicken livers and set in a small bowl.
Slice lime very thin.
Sauté sliced tortilla chips in corn oil and set on paper towel.
Serve soup hot with sautéed tortilla chips on top.
Set small dishes of chopped cilantro, lime slices, and chicken livers to be served with soup and warm tortillas.
Serves 4.

Turkey-Bean Minestrone Soup

This is a wonderful way to use the final leftovers of a big turkey dinner. Using dried beans rather than canned is a bit more work but gives the soup a much heartier flavor. The soup freezes well, so it's worth the effort.

> 1 turkey carcass with plenty of meat, plus any
> additional leftover turkey
> 5 quarts water
> 3 bay leaves
> 1 16-ounce bag great northern beans
> 1 16-ounce bag garbanzo beans
> 1 16-ounce bag kidney beans
> 1 28-ounce can stewed tomatoes, or 6 large fresh
> tomatoes, chopped
> 2 large onions, chopped
> 4 large cloves garlic, chopped
> 1 head cabbage, sliced
> 1 teaspoon each pepper and seasoned salt
> Dash of salt
> 1 tablespoon fresh basil, chopped
> 1 box rotelle or fusilli pasta
> Fresh grated Parmesan cheese
> Juice of 1–2 large limes

Soak beans overnight in water to cover (or use quick-soak method).

Add turkey carcass, bay leaves, and water to a large soup pot and bring to a boil.

Reduce heat to low and simmer for 1 hour.

Remove carcass and let cool. Strain broth back into soup pot.

Trim meat from carcass; add to broth along with leftover turkey.

Add the beans, onions, and garlic and cook over medium heat for 1 hour or until beans are becoming tender.

Add cabbage, tomatoes, herbs and spices, and noodles and cook until beans and noodles are done.

Serve piping hot with a sprinkle of Parmesan cheese and a squeeze of lime.

Salads

"*Lettuce is like conversation: it must be fresh and crisp,*
so sparkling that you can scarcely notice the bitter in it."

—*Charles Dudley Warner*
My Summer in the Garden *(1871)*

SALADS! Always use the freshest ingredients available. This is a course in the meal to whet your appetite. Or, European style, a course to cleanse your palate before dessert. Salad can be plain and simple, a work of art, a whole meal. The variety of salads is unending. The most important feature of the salad is that it complements the whole meal.

I think the best salad in the entire world is my mother's green salad. At every family reunion, potluck, or special occasion, there was no question about who would bring the salad. Generally, the salad was Bobo's (my mother's) special green salad, but sometimes it was potato salad, and sometimes it was both.

For years I feasted on her salad, while the ingredients sat out on the kitchen counter. Often Mom and I would be in the kitchen talking while she was making salad. I watched olive oil, wine vinegar, garlic salt, seasoned salt, and fresh ground pepper being put on the salad with a final squeeze of lemon. Tossing and serving the salad seemed second nature to my mother, and the salad was always perfect.

Once when Mom was visiting and we were again in the kitchen, I asked her to make the salad. Perfect again, so I asked for the recipe. She said, "Oh, a little of this and some of that," picking up the same ingredients on my counter as she had in her kitchen. "How much of each?" I asked. "Oh, you'll know when it tastes right."

Mother died shortly after that visit, and I was terribly homesick for her cooking. Experimenting with salad and the dressing proved frustrating until one day it was just right. Of course, I wrote down the entire recipe so that it could be passed on to my daughter and grandchildren and shared with generations to come.

My favorite salad uses my mother's recipe, with one exception—using lime instead of lemon. This prize-winning salad, using prize-winning LCV limes, was featured in the *Santa Barbara News-Press* in the "Cook of the Week" Column. I still make the salad exactly as Mom did, substituting lime, and it gives me that feeling of being close to her and "home" cooking. This recipe appears here as Lime Vinaigrette Salad.

Advance preparation is an especially important part of salad making. Washing the ingredients ahead of time is very important in making salads because water on the lettuce can change the taste of a recipe.

In many of the following recipes, the instructions suggest patting the lettuce leaves dry or laying them on paper towel to drain, and then placing them in the refrigerator for at least four hours. I call this crisping. A wet, soggy salad just isn't appetizing. A crisp salad is the best salad.

Lime Vinaigrette Salad

This salad was a prize winner at the Santa Barbara Fair and Expo. The limes used in the salad won a blue ribbon at the same fair. People who read the recipe often say, "Your salad is too much work." However, the results are worth the effort. Remember the dressing is made ahead and can be used for at least three more salads.

> 1 head lettuce—iceburg, red leaf or green leaf
> 1 large tomato, cut into bite-size pieces
> ½ red onion, chopped
> 2 small carrots, cut in half and grated
> ½ head red cabbage, sliced
> ½ yellow bell pepper, sliced
> ½ red bell pepper, sliced
> ½ green bell pepper, sliced
> 1 tablespoon each fresh basil, oregano, thyme,
> cilantro, and parsley, chopped

Wash all ingredients and dry on paper towels.

Wrap lettuce and vegetables (except the tomato) in paper towel and place in a bowl.

Refrigerate for at least 4 hours or as long as possible to crisp the salad mixings.

Remove from refrigerator and drain any water from bowl.

Tear lettuce leaves into salad bowl.

Prepare other vegetables and add to the bowl.

Toss salad.

Pour about ¼ cup of Lime Vinaigrette Dressing (see page 143) over the salad and toss again.

Serve on salad plates.

Serves four generously as a salad course.

Menu Suggestions
Add chicken, fish, or garbanzo beans for a complete meal.

Fruit and Butter Lettuce Salad

2 heads of butter lettuce
1 small tomato, sliced thin
½ red onion, chopped
6 strawberries, sliced
1 grapefruit, segments cut in pieces
1 orange, segments cut in pieces
1 apple, cored and chopped
1 avocado, sliced
1 medium lime and thin lime slices
8 dates, pitted and sliced
1 tablespoon parsley and thyme; save extra sprigs for
 garnish
½ teaspoon seasoned salt and garlic salt
1 teaspoon fresh ground pepper
Light Vinaigrette Dressing (see page 144)

Wash all ingredients, drain, and place on a paper towel.
Refrigerate lettuce wrapped in a paper towel for at least four hours.
When you are ready to prepare salad, tear lettuce, add herbs, tomato, and fruits except avocado, apple and lime.
Just before serving, slice avocado, and chop apple and dates, and add to salad.
Squeeze lime juice over salad.
Toss well, add Light Vinaigrette over salad, and toss again.
Garnish with a thin slice of lime and herbs.

Simple Green Salad

1 head iceburg lettuce or lettuce of your choice
1 large tomato, sliced
½ medium lime
¼ cup extra virgin olive oil
1 tablespoon red wine vinegar
¼ teaspoon each garlic salt and seasoned salt
Ground pepper to taste

Wash lettuce and tomato.
Drain lettuce and wrap in a paper towel.
Put in a salad bowl and drain all water from the bowl.
Refrigerate lettuce to crisp up.
Tear lettuce into bowl and add tomatoes.
Squeeze lime juice onto lettuce.
Add olive oil and red wine vinegar.
Add seasonings and toss well.
Serves 3–4.

Basil and Tomato Salad

This salad is especially savory with chicken and pork and barbecues.

4 large tomatoes, sliced (Beefsteak preferred)
½ cup pine nuts
½ cup fresh basil, chopped, leaving a few whole
 leaves for garnish
½ cup extra virgin olive oil
⅛ cup red wine vinegar
1 teaspoon fresh ground pepper
1 teaspoon salt
Juice of 1 medium lime
Lettuce leaves

Wash tomatoes.

Mix all ingredients except basil and pine nuts in a cruet or small jar. Chill well.

When ready to prepare salad, put freshly washed lettuce leaf on each salad plate.

Pour dressing over tomatoes and lettuce.

Sprinkle chopped basil and pine nuts over each salad and garnish with whole basil leaves.

Serves 4.

Butter Lettuce Salad
with Herbs and Watercress

This is a light, refreshing salad and particularly good with roast chicken, leg of lamb, or fish such as salmon, sole, or lobster.

 1 or 2 heads of butter lettuce, depending on size
 1 large tomato, sliced
 1 bunch watercress, stems removed
 ½ cucumber, scored and sliced thin
 ⅓ cup extra virgin olive oil
 1 tablespoon white wine vinegar
 Juice of ½ medium lime
 ¼ teaspoon seasoned salt and garlic salt
 Ground pepper to taste
 1 teaspoon parsley, tarragon, basil, and thyme, chopped

Wash lettuce, tomatoes, cucumber, and herbs.

Drain on a paper towel.

Wrap lettuce, vegetables, and herbs in a paper towel and place in a bowl.

Crisp in the refrigerator as long as possible.

Tear lettuce into a bowl. Score and slice cucumber and add to salad. Add seasoning and herbs.

Squeeze lime on salad. Pour olive oil and white vinegar over salad. Add watercress and toss well.

Serve on salad plates and garnish with tomato slices, sprigs of herbs, and watercress.

Serves 4.

George's Caesar Salad

This recipe originally belonged to George Hebel. George was a maitre d' in Marin County and made many Caesar salads. George made this dressing for a dinner party one evening when he was a guest in our home. He told me how to make the dressing that evening. When I make this dressing it is always close, but never exactly like George's. It's especially good served with beef, chicken, or lamb. You can serve the salad with garlic bread for lunch as a full meal for two.

1 head romaine lettuce
4 small tomatoes, sliced
1 bunch green onions, sliced
¼ pound mushrooms, sliced
Salt
Pepper
1 large clove garlic, chopped, plus 1 large clove cut in
 large pieces
Anchovy paste to taste
½–1 tablespoon dry mustard
1 tablespoon Worcestershire sauce
¼ cup mayonnaise
¼ cup red wine vinegar
¼ cup extra virgin olive oil
2 ounces pasteurized egg yolk
Juice of 1 large lime
Fresh grated Parmesan cheese

Chill a small stainless steel mixing bowl.

Wash greens and vegetables and pat dry with a paper towel.

Crisp in the refrigerator for at least 4 hours.

In the chilled mixing bowl, add salt and ground pepper.

Cut garlic into large pieces and rub inside chilled bowl and remove.

Add Worcestershire sauce, anchovy paste, chopped garlic, and dry mustard.

Use a whisk to mix the remaining ingredients in order, except the cheese. Blend after each addition.

Tear greens into a salad bowl and add vegetables.

Pour Caesar dressing generously over salad and toss.
Add Parmesan cheese and toss well.
Serve on chilled salad plates and sprinkle Parmesan cheese over
the top of the salads.
Serve remaining dressing in a glass jar.
Serves 4.

Spinach Salad with Mustard Vinaigrette

1–2 bunches spinach, washed well
3 cups mushrooms, sliced thin
1 medium tomato, sliced
½ cup crumbled bleu cheese
1 teaspoon dry mustard
2 tablespoons red wine vinegar
½ cup olive oil
1 medium lime
¼ teaspoon garlic salt and seasoned salt
Generous amount of fresh ground pepper

Wash spinach well. If using prewashed spinach, still wash well.
This salad can be prepared without crisping, although crisping always makes the salad taste better.
Wash and dry mushrooms, slice, and set aside, not in the refrigerator.
Wash lime and tomato.
Remove the stems from the spinach and tear leaves into a stainless steel bowl.
Add mushrooms and tomatoes.
Squeeze lime juice on the vegetables and add seasonings.
Pour olive oil over salad.
In small jar, blend mustard and vinegar and shake well.
Pour over salad.
Toss salad well and serve on individual salad plates.
Crumble bleu cheese over each salad.
Serves 4.

Menu Suggestions
This salad is delicious with marinated chicken, baked ham, pork steaks, or served as a main course adding tuna, chicken or protein of your choice. The salad can be made faster if you prepare the dressing ahead of time (see Mustard Vinaigrette Dressing, page 145).

La Collina Verde Pasta Salad

Check "Creative Leftovers" for ideas on serving this salad as a main course—
it's a recipe with unlimited variations. We cook larger amounts of pasta and
our main course, so that we have enough of both leftovers to add to this salad
the next night for our dinner.

1 box fusilli or fettuccine (if not left over from
 previous meal)
1 large tomato, sliced
1 tablespoon each fresh basil, rosemary, thyme, and
 parsley, chopped
1 large lime
½ teaspoon each garlic salt and seasoned salt
Fresh ground pepper to taste
¼ cup red wine vinegar
¾ cup extra virgin olive oil
½ cup Parmesan cheese, grated
½ cup Gorgonzola cheese, crumbled

Wash tomato and herbs and set on paper towel to dry.
Cook pasta according to the directions on the box.
Drain and rinse noodles and place in a large pasta bowl.
Add sliced tomato and chopped herbs to the pasta.
Squeeze lime juice over all and season with salts and pepper.
Pour olive oil and vinegar over the salad and toss well.
Refrigerate until well chilled.
Toss well before serving.
Serves 4–6.

Menu Suggestions
Serve as a side dish with salmon, ahi, calamari, chicken, turkey, tri
tip, or other steak.
 Bread with olive oil for dipping.
 Fumé Blanc or Merlot.
 Firestone or Bass ale.

Ginger's Vegetable Toss

1 large head iceberg lettuce, torn into big-size pieces
6 hard-cooked eggs, sliced
Seasoned salt
10 slices bacon, cooked crisp, drained, crumbled
1 cup shredded carrot
2 cups cauliflowerets (1 head)
½ cup thinly sliced radishes
1 cup crumbled Bleu cheese
2 cups shredded sharp cheddar cheese
½ cup mayonnaise or Lime Vinaigrette Dressing (see
 page 143)
½ cup sour cream

In a large salad bowl, layer half the lettuce.
Arrange the egg slices in a layer and sprinkle with seasoned salt.
Layer the bacon, then carrots, cauliflowerets, radishes, and finally the remaining lettuce.
Sprinkle with more seasoned salt.
Top with Bleu cheese, then cheddar cheese.
In a small bowl, mix mayo or salad dressing and sour cream until blended.
Spread over the cheese layer, sealing to edges of the bowl.
Cover, refrigerate up to 24 hours.
Serves 12.

Santa Barbara Fruit Salad

Serve this salad with roast chicken or Grammie's chicken, or turkey. It's also excellent for lunch with toasted cheese sandwiches. Other fruits can be added to this salad depending on what is in season. For variety try melon, cherries, figs, raspberries or boysenberries.

4 large oranges, peeled and cut into segments
1 pineapple, cut into bite-sized pieces
1 large bunch of grapes, stemmed
4 kiwis, peeled and sliced
2 baskets strawberries, sliced
4 plums, quartered
4 nectarines, peeled and quartered
2 apples, cored and sliced
4 bananas, peeled and sliced
1 large lime

Wash berries, nectarines, plums, grapes and apples.
Prepare all fruit except bananas and apples.
Put fruit into a glass serving bowl and refrigerate.
Add apples and bananas just before serving.
Squeeze lime juice on the fruit salad and blend all the fruit together to keep the fruit from turning dark.

Fresh Veggie Salad

A squeeze of lime brings out the flavor of the seasonings and herbs and, along with the vegetables, provides a light dressing effect. This is a great diet salad. You can add 2 cups of plain yogurt, which also enhances the flavors of the lime, vegetables, and herbs.

If you want a heartier salad, add tuna, chicken, or beans and Lime Vinaigrette Dressing.

1 large tomato, sliced and cut into bite-sized pieces
2 stalks celery, chopped
4 carrots, chopped
1 red pepper, sliced
1 yellow pepper, sliced
½ head red cabbage, chopped
2 zucchinis, sliced thin
2 green onions, sliced
1 medium lime
½ teaspoon seasoned salt and garlic salt
Fresh ground pepper to taste
1 tablespoon each parsley and cilantro, chopped

Wash and pat dry all ingredients with a paper towel.
Refrigerate in a glass serving bowl and crisp as long as you can.
Remove from refrigerator and add vegetables.
Squeeze lime juice over vegetables.
Add seasonings and herbs and toss well.
Refrigerate until ready to serve.
Serves 4–6.

Vegetables

"Eat every carrot and pea on your plate."

—Bertha Peterson

VEGETABLES are essential to a well-balanced diet and meal plan. Experimenting with vegetables whets the appetite. There are as many ways to cook, season, and serve vegetables, as any other food. But I think the perfect way to cook vegetables is to steam until just tender and serve with melted butter and/or a squeeze of lime.

Vegetables seem to draw a stronger reaction, pro or con, than any other food group. Almost everyone I've talked with has a dreaded vegetable they were forced to eat as a child and hate to this day. With the year-round availability of most vegetables, it seems to me a dreadful waste of time and energy to force anyone to eat something they can't stomach, never mind ruining mealtime.

While writing this book I had the good fortune of interviewing Bob Wingate, who was then the produce manager of Scolari's, a local grocery store. Bob was generous with his time and information, and he allowed me to share with you these tips on caring for vegetables.

Vegetables are made up of anywhere between 50 and 90 percent water. Some of this water dissipates between harvest and arrival at a store.

Water is added back into the vegetables by soaking in a sink of warm water, after trimming damaged portions.

The key to healthy produce is to wash well before using.

Drying the produce on paper towels before refrigeration removes excess water.

Leafy vegetables are better crisp. To do this soak, drain, and refrigerate.

Washing and thoroughly drying vegetables before cooking give a purer taste, as water will dilute recipes.

Most vegetables, except root vegetables, are best used within two to three days of purchase.

Mushrooms should be washed just before use. They get spongy and soggy if washed and then refrigerated.

Green beans will mold if washed and then stored in the refrigerator.

Potatoes can be sliced and stored in cold water with salt up to four hours without browning.

On the following page is a "short list" of vegetables I like to cook simply. Most are cooked perfectly when steamed, and I've noted the cooking times here because some vary.

Asparagus
Wash asparagus, snap off ends, and put in a steamer.
Steam for 4–10 minutes, depending on the size of the stalks.
Drain and serve with melted butter, a squeeze of lime, or Lime Hollandaise Sauce (see page 145).

Broccoli
Wash broccoli, cut off stems, and put in steamer.
Steam for approximately 10 minutes.
Drain, and serve with melted butter, a squeeze of lime, or Lime Hollandaise Sauce (see page 145).

Carrots
Wash carrots and peel if desired.
Cut into 1-inch pieces and put in a steamer.
Steam for 15–20 minutes.
Drain and serve with melted butter and fresh thyme.

Cauliflower
Wash, remove stem, cut into flowerets, and put in a steamer.
Steam for 10–20 minutes or until tender when pierced with a fork.
Drain and serve with melted butter or white sauce.

Green Beans
Wash and snap or cut ends and remove string.
Put in a steamer and steam for 10–20 minutes.
Drain and serve with butter or olive oil and a squeeze of lime.

Potatoes
Wash potatoes and peel if desired.
Cut into quarters and put in a steamer.
Steam for 30 minutes or until tender when pierced with a fork.
Drain and serve with melted butter and fresh parsley.

Zucchini
Wash and slice zucchini.
Put in a steamer and steam for 5–10 minutes.
Drain and serve with melted butter and a squeeze of lime.

Artichokes with Lime
and Soy Mayonnaise

At breakfast at the Rose Café on Sunday morning, Pete and I were talking with two friends, Dick Von Hake and Karen Finell. We were talking about how important it is to read and understand the directions of a recipe. We began to exchange funny stories, and Dick Von Hake's story about his parents is the perfect example of what can happen when you take a recipe literally.

Mr. Von Hake gave these directions over the telephone to his new bride: Cook artichoke just as you cook cabbage, about 40–50 minutes. Drain the artichokes and serve them each in a separate bowl. Serve with melted butter.

When he came home from work and was served the artichokes, he asked, "What on earth is this?" Artichokes! Mrs. Von Hake had cooked the artichokes just as she did cabbage. Cut up in bite-size pieces—leaves, heart, thistle, and all!

Here is a recipe that will make your guests happier than Mr. Von Hake.

4 large artichokes
1 garlic clove
Dash of olive oil
1 cup mayonnaise
Juice of 1 large lime
1 tablespoon soy sauce

Wash artichokes and cut off the stems, so they will sit upright.

Put artichokes in a large pot, fill with water to cover half of the artichokes.

Add garlic and olive oil.

Bring water to a boil, turn to low heat, cover, and cook for 30–40 minutes.

When you can pierce the bottom of the artichoke with a fork, it is done. Don't overcook.

Drain and set in separate serving bowls.

In a small bowl, mix the mayonnaise, lime juice, and soy sauce.

Serve with lime mayonnaise and drawn lime butter (see page 150).

Provide an extra plate or bowl for discarded leaves and choke.

Lime and Garlic Sautéed Chard

2 large bunches chard
4 cloves garlic, chopped
2 medium limes
Olive oil

Wash chard well and drain on a paper towel.
Take the spine out of chard and tear leaves into pieces.
Put olive oil in bottom of large frying pan and heat on low.
Sauté garlic until golden.
Sauté chard about 7–10 minutes.
Squeeze limes over chard and serve in a vegetable dish.

Nopales

Augustin Porras, a happy, kind, and loving man, taught us how to use this giant cactus. When Augustin brought a delicious pork and nopales dish that he had cooked up especially for Pete and me, he asked, "Why don't you eat this?" We did, and then asked him, "Why don't you show us how to prepare the cactus?" And he did. He showed us how to clean the nopales and how to use the fruit, prickly pears, by adding lime juice and salt.

Nopales are the leaves of the prickly pear cactus. Choose young leaves, which are lighter green than the leaves from previous years.

To harvest, hold the leaves with tongs and cut off with sharp knife. Put leaves in a brown bag as you harvest them. Be careful of the thorns.

Clean nopales by cutting around the edge of the leaf with a sharp knife to remove the thorns on the edge. Then slice the rest of the thorns off the flat sides of the cactus leaf. Be sure all thorns are removed.

Slice nopales in ½-inch slices about 2 inches long.
Wash slices.
Put in a saucepan and cover with cold water.
Add garlic and olive oil and bring to a boil.
Reduce heat to medium and cook for exactly 10 minutes.
Drain and rinse well.
Serve with melted butter or olive oil and a squeeze of lime, if desired.

I cook a large amount of nopales and refrigerate the leftovers. At a later time I chop nopales and add chopped fresh tomatoes, onions, the juice of 1 lime, and just enough olive oil to coat the vegetables. It becomes a different, tasty salad.

Baked Zucchini

1 large zucchini (1–2 pounds)
2 tablespoons melted butter
¼ cup white wine
1 medium lime
⅛ teaspoon garlic salt
¼ teaspoon seasoned salt
½ teaspoon fresh ground pepper
½ teaspoon each fresh parsley, savory, rosemary,
 thyme, and oregano, chopped
½ cup fresh grated Parmesan cheese
Paprika for color

Preheat oven to 350 degrees.
Wash the zucchini and cut in half lengthwise.
Lay in a baking pan and score with a fork.
Squeeze the lime on both halves of zucchini.
Pour the wine over zucchini halves.
Pour butter over zucchini halves.
Sprinkle the herbs on the zucchini.
Cover with Parmesan cheese and sprinkle paprika over the
zucchini for color.
Bake at 350 degrees for ½ hour, or until tender when pierced with
a fork.

Menu Suggestions
Basil and Tomato Salad
Caryl's Red Potato Bake
Slavonic Steak

Jan's Cheese-Stuffed Zucchini

Jan likes to do needlepoint, and I like to garden. I gave Jan some zucchini from my garden, and she made this recipe and brought it to a picnic at Tucker's Grove—along with a birthday present for me. When I opened the gift, I found a pair of gardening gloves stitched with the message, "Gardening is a dirty job, but somebody has to do it."

1 large zucchini (at least a pound)
¼ cup onion, chopped
1 tablespoon butter
¾ cup cottage cheese
1 cup cooked rice
1 egg, beaten
1 tablespoon fresh parsley, chopped
1 teaspoon fresh basil, chopped
¼ teaspoon salt
Juice of 1 medium lime
Cheddar cheese

Preheat oven to 350 degrees.

Sauté onion in butter until limp and transfer to a mixing bowl.

Halve zucchini and scoop out seeds and some of the pulp and discard.

Steam or microwave the zucchini until they just begin to soften, about 4 minutes.

While the zucchini cooks, mix all ingredients except the cheddar cheese in the bowl with the onion.

Fill zucchini halves with the mixture.

Bake, covered, in a shallow dish for 30 minutes.

Remove cover, top with cheddar cheese, and bake for 5 minutes more.

Battling Bobbie's Garlic Beans

My father, Bobby Seigel, was the fourth-ranked world featherweight boxer, and, because of his consistent wins and knockouts and vigorous fighting style, was dubbed "Battling Bobby" in the press. My family vacationed at a place called Gilman Hot Springs in the San Jacinto Mountains of Southern California. This was a pure, wonderful place in the desert where kids could roam free looking for "fool's gold," swim, and ride horses while our parents played golf or took the mineral baths.

One of the family's favorite dinner spots was the Ramada Inn. My dad loved the garlic beans that were served there. He would go home and mix up a batch, and we all tasted and ate till we were blue in the face. It really didn't matter that we all smelled like garlic, since garlic was always "spoken" in our house. Finally Dad perfected his beans.

One year at a family reunion at Aunt Bonnie's, Dad's dish to carry was garlic beans. I took what was left over in my car. The container lid was not tight, and the beans spilled on the carpet. The car wash couldn't remove the odor—Energine, heavy cleaners, nothing took the odor out. I was riding to work in a car pool at the time, and no one would ride with me. I sold the car!

1 pound dried garbanzo beans
1 pound dried great northern beans
1 pound red kidney beans
4 large limes
8 large garlic cloves, chopped
1 large white onion, chopped
1 cup red wine vinegar
½ cup olive oil
1 tablespoon seasoned salt
2 teaspoons salt
2 teaspoons fresh ground pepper
3 tablespoons fresh parsley, stems discarded
Rolaids for garnish, optional

Wash and sort the beans according to the directions on the package.

Cover beans with water (about 2 inches over beans) and soak overnight, or use the quick-soak directions on the package.

Drain beans and rinse.

To a large soup pot, add the beans and cover with water.

Bring to a hard boil, reduce the heat, and skim the fluff that rises to the surface.

Cook on low until beans are tender, about 1½ hours.

Be careful not to overcook the beans because they get pasty and the dish looses its appeal.

Now comes the fun part.

Drain the beans, saving about 1 cup of the water.

Rinse the beans well.

Put beans in a huge mixing bowl.

Squeeze the juice of 4 limes over the beans.

Add the garlic, onions, vinegar, and oil and stir well.

Add the salts, pepper, and parsley.

Mix and taste, see what you think, but don't do a thing.

Refrigerate for a few hours and taste again.

Season to taste.

Cover well and refrigerate until ready to serve.

Much like a marinade, this dish picks up *power* and taste and is better made a day in advance.

The Entrée

THE ENTRÉE, while not the beginning of the meal as the word implies, is the most important part of the meal. James Beard, one of the world's most famous cooks, says that if your main course is not good, every other part of the meal will taste inferior as well.

The entrée dictates what other dishes will be served. I once attended a dinner party where the hostess used phyllo pastry for the hors d'oeuvres, the main course, and the dessert. Each was tasty, but each took away from the others.

As a novice cook, I once served the following meal to my parents, both excellent cooks:

Green salad with Thousand Island dressing
Pork chops and white gravy
Mashed potatoes and white gravy
Green beans with mushroom sauce
Custard

I noticed that nobody was tasting the gravy, and when I picked up the gravy boat, the gravy wouldn't pour—it was set like concrete. The good news was the mushroom sauce was tasty. More bad news was that the custard looked like the gravy. There was too much of the same color and texture. A little meal planning would have gone a long way.

Planning a meal that is harmonious and interesting is a real talent. I have included menu suggestions with many of the recipes to give you some ideas for meal planning.

Fish

"Fish are like relatives. After three days, you need to throw them out."

—*Unknown*

The beauty of the lime as a companion fruit is that it enhances the natural flavor of the food, and when using lime with fish you can virtually cook without using any other seasoning. Sometimes the simplest form of cooking is the best. Still, cooks enjoy experimenting with herbs and spices and fruits and vegetables to create a beautiful and delicious presentation of fish.

The choices and availability of fish were limited until quite recently, so fish was not a major part of many people's diets. Frying and breading seemed to be popular ways to prepare fish. This has changed, partly because of health consciousness, and partly because of greater availability. Now there are fish markets selling fresh fish flown from Hawaii, New Zealand, Chile, and other exotic parts of the world.

Fish is now a desirable choice for the home cook, and experimentation flourishes. Appetizers, stews and soups, entrées, and even a breakfast of fish have become well liked and accessible.

Experiment with the recipes in this chapter, remembering that recipes are often an approximation—chefs and gourmets are notorious for "tweaking" recipes. Or try the delicate taste of fish with just a simple squeeze of lime and enjoy.

Andy's Ceviche

My neighbor's son-in-law was having a party and needed limes. He called to see if he could have some, so we all went out into the orchard and picked the limes. Andy thanked me for the limes and asked what he could do to repay me. I said "Give me your ceviche recipe and let me use it in my book." A week later Andy showed up at the door with this delicious recipe.

Juice of 8 limes
1 pound halibut or albacore, very fresh
2 bell peppers (red or orange)
4 large tomatoes
1 bunch cilantro
2 cloves garlic
1 red onion
Sea salt
Pepper

Cut fish into ½-inch-by-¼-inch cubes. Place in bowl.
Add lime juice.
Refrigerate for 4 hours. The acid in the lime "cooks" the fish.
Dice everything else fairly fine.
Combine vegetables and seasonings with fish and chill at least 1 hour.
Serve with fresh bread and butter as a first course.

Sharon's Peel-and-Eat Shrimp

This is my all-time favorite dish prepared by Sharon Campbell. She and Jerry served this at a dinner party where the table was elegantly set with fish nets, seashells, and sand candles. Sharon enjoys entertaining with a flair, and we had a messy but wonderful time eating the shrimp. Sharon is a longtime friend, one I call a "gift friend" because we met through the gift of our daughters' friendship.

 1 pound large shrimp (about 16–18)
 1 teaspoon salt
 Fresh ground pepper
 ½ teaspoon sugar
 Olive oil
 Lime wedges

Wash shrimp, remove legs, and devein.

Put shrimp in a large bowl of ice water and refrigerate for at least 2 hours.

Remove from refrigerator and drain shrimp well on paper towels.

Sauté shrimp in a large pan with a small amount of olive oil until just pink.

Remove to a bowl.

Wipe out the pan, leaving a small amount of oil.

Add the salt, pepper, and sugar and mix well over medium heat.

Return shrimp to the pan and stir with the spice mixture, coating well, for about a minute.

Serve immediately with lime wedges, lots of napkins, and an extra bowl for the peels.

Scotty's Shrimp

1 pound medium shrimp
Juice of 2 limes
Salt
Pepper
2 cloves of garlic, chopped
Olive oil

Clean and devein shrimp.
Soak wooden skewers in water.
Marinate shrimp in lime juice, salt, pepper, and garlic for 4 hours.
Skewer shrimp on wooden sticks.
Coat with olive oil.
Barbecue until the shrimp turn pink, basting often with the marinade.
Serves 4 as a light main course.

Lime Scampi with Angel Hair Pasta

1 pound prawns, peeled and deveined (about 16–18
 prawns)
¼ cup olive oil
1 large tomato, chopped
1 large lime
3 tablespoons fresh basil, chopped
3 tablespoons fresh parsley, chopped
2 cloves garlic, chopped
1 pound angel hair pasta
¼ cup Parmesan cheese

Rinse shrimp and dry on paper towels.
Squeeze lime juice on shrimp, cover well, and refrigerate.
Cook angel hair pasta, drain well, place in a serving bowl, and set
in oven on 200 degrees.
Sauté garlic in olive oil until golden.
Sauté shrimp until light pink.
Add shrimp, garlic, and olive oil to angel hair pasta.
Add basil, parsley, and tomatoes.
Add Parmesan cheese and mix well.
Serve with a wedge of lime.

Menu Suggestions
Carlton's Honey Balsamic Vinaigrette Salad Dressing (page 144)
French bread and olive oil for dipping
Fumé Blanc or Chardonnay.
Sherbet Cake

Cheri Hollywood's Cioppino

Cheri and Stan like to cook at home, and of the many delicious meals I've enjoyed there, this is the one I like best. My favorite time to visit is for their "Hollywood's Annual Trim-a-Tree Party," when they share their love for the true meaning of Christmas in their festive, beautifully decorated home.

1 large onion, sliced thin
1–2 bunches green onions, sliced (include tops)
2 large cloves garlic, sliced in half
⅓ cup olive oil
1 8-ounce can tomato paste
1 16-ounce can tomato pureé
2 cups dry red wine
1 cup water (add more, if necessary, as the sauce
 cooks down)
¼ cup fresh chopped parsley
2 bay leaves
½ teaspoon dry basil
⅛ teaspoon dry rosemary
⅛ teaspoon dry thyme
Dash of paprika
Salt and pepper to taste
Juice of 1 large lime

In a large pot, sauté onions and garlic in oil over medium-high heat for 5–7 minutes.

Add the rest of the ingredients.

Cover and simmer over low heat for at least an hour (best if simmered 3–4 hours).

About 30 minutes before serving add:
½–1 pound crab
1–1½ pounds prawns (16–18 per pound)
12–18 small clams, thoroughly scrubbed
1 pound scallops
¾–1 pound firm fillet of white fish, like halibut

Simmer gently for 15–25 minutes, or until the fish is cooked and the clams open.

Add the lime juice just before serving, if desired.

Serve with lots of napkins, green salad, and French bread.

Fresh Idaho Trout

4 fresh Idaho trout (caught the day of cooking for
 the ultimate taste)
2 medium limes
2 cloves of garlic, chopped
1 tablespoon each fresh thyme, oregano, and parsley,
 chopped.
½ cup Fumé Blanc
½ cup butter
½ teaspoon seasoned salt
½ teaspoon garlic salt
½ teaspoon fresh ground pepper
Limes and herbs for garnish

Preheat oven to 350 degrees.

Wash trout, dry with a paper towel, and set each fish on a square of aluminum foil.

Melt butter in small sauce pan and add garlic and herbs.

Squeeze ½ lime over each trout.

Pour wine over each trout.

Pour melted butter, garlic and herbs over each trout.

Season lightly.

Seal trout in the foil.

Bake for 20–25 minutes.

Remove fish from foil and place on a platter or individual plates and garnish with lime slices and herbs.

Menu Suggestions
Butter Lettuce and Watercress Salad
Steamed or sautéed asparagus
Brown rice pilaf
Fumé Blanc or Sparkling Limeade Mist
Kate's Raspberry Lime Pie

Uncle Tom's Heavenly Halibut

Every family should be blessed with an Uncle Tom like Tom Bohn. He is an avid fisherman, cooks, helps with remodeling, plays the piano, ministers, and writes beautiful fun poetry about every family member who attends family reunions. When he was in the Navy, he was on the U.S.S. Los Angeles cruiser. The ship was hit in battle and all we knew was what we read in the headlines of the newspaper. As a child, I remember going all the way to Long Beach to see him and the ship. What a thrill to see him intact and that beautiful smile that said, "It's great to be alive."

1 pound halibut fillet
3 tablespoons lime juice
¼ teaspoon thyme leaves
3 tablespoons olive oil
¼ teaspoon garlic salt
Dash fresh ground pepper

Combine all ingredients and marinate fish for at least 30 minutes.
Leave fish in marinade and broil 5–6 minutes per side, depending on thickness of fish.
Fish should be firm to the touch.
Garnish with lime slices.

Sea Bass with Lime-Fruit Compote

2 pounds sea bass
2 medium limes
½ cantaloupe, chopped in small pieces
1 cup red grapes, cut in half
½ red onion, chopped
1 red apple, chopped in small pieces
¼ cup cilantro, chopped

Wash sea bass and set on a paper towel.
Wash and prepare fruit.
Combine fruit and cilantro in a bowl and squeeze juice of 1 lime over compote.
Set in refrigerator.
Squeeze juice of l lime over sea bass and broil 4–6 minutes on each side.
Cut fish into 4 servings.
Set on plates and spoon fruit compote over sea bass.

Lime Snapper Veracruz

1¾ pound whole red snapper or snapper fillets
1 large lime
Flour as needed
4 corn tortillas
1 cup grated cheddar cheese
¼ cup olive oil
1 medium onion, chopped
2 cloves garlic, chopped
1 teaspoon seasoned salt
Generous amount of fresh ground pepper
Irmal's Salsa Fresca (page 149)

Preheat oven to 350 degrees.
In a large frying pan sauté onion and garlic in olive oil until golden.
Flour fish on both sides and season with salt and pepper.
Sauté in onion and garlic, and squeeze juice of lime over fish.
Brown for about 5 minutes on each side.
Do not let fish get flaky.
Set fish on a plate covered with a paper towel to drain.
Cook tortillas on griddle pan until soft.
Line a casserole dish or 4 individual casserole dishes with tortillas.
Lay snapper on the tortillas and cover with onion and garlic.
Cover with shredded cheese and bake for 30 minutes.
Serve with Irmal's Salsa Fresca.

Limed Hawaiian Escolar

This is an excellent delicate fish that is best if bought the day you plan to serve it, so carefully select your finest fish market in town. Very similar to Uncle Tom's Heavenly Halibut, but no oil is needed because this fish has a high oil content.

4 1-inch fillets escolar
2 medium limes
Seasoned salt and garlic salt
Fresh ground pepper
Lime thyme and lime slices

Preheat oven to 350 degrees.
Rinse fish and place in Pyrex dish.
Squeeze ½ lime on each piece of fish.
Season very lightly.
Bake for 7–10 minutes on each side.
Place on fish platter and garnish with lime thyme and lime slices.

Oven-Fried Halibut
with Lime Cilantro Butter

This fish is delicate and delicious without any seasoning except a squeeze of lime and cilantro butter melted over the top of the fish.

4 pieces halibut, 1–1½ inches thick (about 2 pounds)
Olive oil
2 medium limes, 1 sliced for garnish
½ cube butter, softened
1 tablespoon fresh cilantro, plus leaves for garnish

Preheat oven to 500 degrees.
Pour ⅛ inch olive oil into a baking pan.
Rinse halibut, dry, and put into pan.
Cook for about 10 minutes.
Remove to dinner plates and top each piece of fish with a pat of cilantro butter.
Garnish with lime slices and cilantro leaves.

Cilantro Butter
See page 150.

Menu suggestions
Spinach Salad with Mustard Vinaigrette
Steamed asparagus
Orzo
Lime Custard with chocolate sorbet and raspberry sauce
Fumé Blanc or mineral water with lime.

Salmon La Collina Verde

This is probably my best fish recipe, and most guests who have eaten this Salmon La Collina Verde rave about the taste. In this recipe, and in any recipe using wine, I always follow Julia Child's advice to always use good wine, a wine you would be happy to drink. It doesn't need to be expensive, but it should have good flavor, because that flavor is concentrated as the food cooks.

During the tenth year of working on this book, I decided to try to contact Julia Child. One day I was feeling brave and I picked up the telephone and dialed Julia Child's phone number. A woman answered and asked who was calling. I told her, "Linda Peterson," thinking, "as if that mattered." Julia came on the phone, and I became babbly and finally asked her to come for dinner to taste my salmon recipe because I was writing a cookbook. Julia said, "Thank you for the invitation, but I'm leaving for the east coast next week. What is your cookbook about?" I timidly said "Limes." Julia said, "Splendid idea."

After the call I just sat in a daze listening to that distinctive voice over and over in my head. The person who has always been my hero said, "Splendid idea." She has done more for the food industry and cooking than any other person in the world. She was my hero before the conversation, and I shall cherish that short talk with Julia Child the rest of my life.

1 5–6 pound salmon, head and tail removed, skin
 intact
2–4 cloves garlic, chopped
2 medium limes
½ cup dry white wine
¼ cup melted butter
½ teaspoon seasoned salt
Generous amount of fresh ground pepper
1 tablespoon each fresh parsley, thyme, and oregano

Preheat oven to 350 degrees.
Wash salmon with cold water.
Set in large piece of tin foil.
Melt butter and add chopped garlic and herbs and pour over salmon.
Squeeze limes over salmon.
Pour wine over salmon.

Season with salt and fresh ground pepper.
Wrap foil tightly around fish, making sure both ends are tight.
Bake in the oven 20 minutes per pound.
May also be cooked on a barbecue grill.

Menu Suggestions
Butter Lettuce Salad
Fettuccine, orzo pasta, or brown rice pilaf
Sautéed asparagus
Fumé Blanc or Cabernet Sauvignon

Bornhoeft's Flying Salmon

This recipe is exciting from the get-go because when we visit Pete's sister and brother-in-law in Seattle, we go down to the Pike Street Market to shop for the entire meal. Caryl and Don pick out exactly the fish they want, and with a big hoopla the fish stall comes to life. "Our" fish is thrown in the air to the wrapper, and while this is taking place, other fish are flying, being tossed from the salesman to the wrapper. There is hollering and bidding almost like an auction. It's fun to be part of the whole process and it seems to make the meal taste extra special.

> 1 4-pound salmon, filleted
> Garlic salt and pepper
> Limes for garnish
>
> **Sauce for basting**
> 1 cube melted butter (½ cup)
> 1 tablespoon Worcestershire sauce
> Pepper
> Onion salt
> Lots of chopped fresh parsley

Open salmon fillet and sprinkle meat side with garlic salt and pepper.

Place on an oiled barbecue grill, meat side down, for about 7 minutes.

Turn salmon onto a piece of aluminum foil.

Baste and cook approximately 15 minutes. Baste often until done.

Serve with lime wedges.

If possible, add damp alder chips to the charcoal for flavor.

Poultry

Claude Monet, the world-famous French Impressionist, was also passionate about cooking and so particular about the foods he cooked or was served that he raised his own poultry.

Standards for processing and cooking chicken have increased because of the risk of salmonella, and I apply those rules to any poultry I cook. Using lime to clean the cutting board that is specifically used just for poultry is an extra safety standard at La Collina Verde. The whole kitchen smells fresh because I also use lime to clean the countertops.

Cooking poultry is probably one of my greatest pleasures because it adds such a "homey" feeling as the aroma wafts through the house as well as outdoors. Also, chicken, turkey, and duck seem to call for mashed potatoes and gravy, buttered carrots, and even a big slice of pie. There is almost no meal that compares to Thanksgiving turkey dinner with all the trimmings.

Of course poultry can be cooked in many ways that are low in calories and cholesterol. Try Limelite Chicken or Diane Brush's Lime-Grilled Chicken for a healthy entrée. If you are looking for a chicken in your pot for a special Sunday dinner, try the Roast Chicken, a succulent delight.

Jennifer's Chicken with Artichokes

This is my daughter's recipe and one of my favorites. Jennifer fell in love with Portmerian dishes as a new bride (she inherited the family's dish fetish and the love for cooking) and served this casserole in her Portmerian serving dish. Even as a little girl she was a natural in the kitchen and loved to bake and cook. When we are fortunate enough to visit her, Michael, Jeffrey, and Natalie, she presents an interesting variety of excellent foods. She makes cooking seem easy and entertains with a special flair. Every mother and father should be as blessed as we are and treated with so much love.

1 pound skinless and boneless chicken, cooked and
 chopped into bite-size pieces
1 tablespoon butter
2 15-ounce cans artichoke hearts, chopped into bite-
 size pieces
½ cup mayonnaise
1 can cream of chicken soup
Juice of 1 large lime
3 tablespoons curry powder
1 box garlic-flavored croutons
½ pound cheddar cheese, grated (optional)

Preheat oven to 350 degrees.
Chop chicken in bite-sized pieces and sauté in butter in frying pan.
Layer a casserole with artichokes.
In a mixing bowl add curry, mayo, soup, lime juice, and mix well.
Add more curry, if needed, to taste.
Pour this mixture over chicken and artichokes.
Cover with cheddar cheese and croutons.
Cover with foil and bake for 45 minutes.

Menu Suggestions
Spinach Salad with Mustard Vinaigrette Dressing
White rice
Fresh French bread

Diane Brush's Lime-Grilled Chicken

Being invited to Diane and Murray's was especially memorable for us because we were on a long road trip. They were friends from Pete's Air Force days, and this was my first visit. The minute we walked into their home there was a warm, welcoming feeling, and conversation was easy and comfortable. Diane and I started talking about recipes, and she invited me into their beautiful kitchen as she cooked with ease, picking the fresh herbs for this chicken right from her garden.

6 skinless, boneless chicken breasts
Juice of 6 medium limes
6 cloves of garlic chopped
½ cup fresh basil, chopped
¼ cup white wine
2 tablespoons butter

Marinate chicken breasts in lime juice, basil, and garlic for 2–8 hours.

Remove breasts from marinade and grill drained breasts 2–3 minutes per side or until cooked through.

While grilling, place marinade in a skillet.

Add butter, chopped fresh basil, and white wine.

Simmer until it is creamy and cook on low 7–10 minutes.

Pour over grilled chicken and serve immediately.

Serves 4–6.

Ginger's Teriyaki Chicken

This recipe was given to me years ago by Ginger Franks. Ginger is a very fine cook, and this is one of Pete's and my favorites.

½ cup orange juice
½ cup olive oil
½ cup soy sauce
½ cup lime juice
2 tablespoons fresh ginger, grated
8 chicken thighs
8 chicken legs

Wash chicken and pat dry with a paper towel.
Combine marinade ingredients in a small bowl.
Put chicken parts in a large Pyrex dish and pour marinade over all.
Cover and refrigerate overnight.
Preheat oven to 400 degrees.
Reduce oven temperature to 350 degrees.
Cook for 30 minutes.
Turn and cook for 30 minutes more.

Menu Suggestions
Light Lime Vinaigrette Salad with fruit and dates
Brown rice pilaf
Matchstick carrots or broccoli
Martinelli's cider, or Hawaiian beer
Lime Ginger Creme Brulée

Limelite Chicken

6 chicken legs, thighs attached
½ cup olive oil
Juice of 4 large limes
Zest of 2 limes
4 cloves garlic, chopped
1 teaspoon cumin
Seasoned salt
Fresh ground pepper

Preheat oven to 375 degrees.
Wash the chicken and put in a baking dish.
Make marinade with remaining ingredients and pour over chicken.
Cover well and refrigerate at least 4 hours or overnight.
Bake for 1 hour, basting frequently.

Jerry's Chicken and Olives

Jerry Campbell is a great guy and great cook. He can barbecue a mean tri tip and he is not afraid to experiment with recipes. Once when he and Sharon were staying in the bunkhouse, we had a cooking party, and he brought a handful of lime flowers to garnish our breakfast plates. He taught me how to collect lime flowers very carefully with tweezers.

4 boneless, skinless chicken breasts
1 8-ounce can of good-quality green olives (or a
 mixture of black and green), pitted and sliced
1 tablespoon olive oil
1 medium lime
½ pound mozzarella cheese, thinly sliced
Olive oil for cooking

Pound chicken breasts between pieces of waxed paper.
Squeeze lime over chicken breasts.
Drizzle olive oil over chicken breasts.
Place sliced cheese over chicken breasts.
Add olives to each chicken breast.
Roll up and secure ends with toothpicks.
Sauté in olive oil till done, 20–30 minutes.
If you like, add a bit of grated mozzarella and a few sliced olives as a garnish.

Lime Herb Chicken

4–6 chicken breasts or legs and thighs
5–6 medium limes
2 tablespoons olive oil
4 cloves garlic, chopped
1 tablespoon each fresh rosemary, oregano, thyme,
 parsley, and cilantro, chopped
½ teaspoon seasoned salt
½ teaspoon key lime pepper (found in specialty food
 stores)
Dash regular salt

Preheat oven to 375 degrees.
Wash the chicken and set in casserole dish.
Mix all marinade ingredients and pour over chicken.
Marinate in the refrigerator for at least 4 hours, best if overnight.
Bake for 1 hour, broiling the last 5 minutes for browning and
crisping if desired.

Roast Chicken

1 large roasting chicken
½ cup dry white wine
½ cup melted butter
½ teaspoon seasoned salt
½ teaspoon fresh ground pepper
1 tablespoon each fresh sage, rosemary, thyme, and
 savory, chopped
1 large lime
2 cloves garlic, chopped

Preheat oven to 350 degrees.
Wash the chicken with cold water and remove the giblets.
Wash and salt the cavity.
Put the chicken on a rack in a medium-size roaster.
Pour melted butter and wine over the chicken.
Squeeze lime over chicken.
Season the chicken and add herbs.
Add chopped garlic and giblets to the pan around the chicken.
Roast the chicken for 2½ to 3 hours, basting often.
As chicken begins to brown, cover with a tent of aluminum foil.

This is an excellent Sunday dinner.

Menu Suggestions
Butter Lettuce Salad
Herbed carrots
Mashed potatoes and giblet gravy
Check "Creative Leftovers" for some wonderful ideas.

Cornish Game Hens

4 large Cornish game hens
½ cup dry white wine
½ cup melted butter
½ teaspoon seasoned salt
½ teaspoon fresh ground pepper
1 tablespoon each fresh parsley, sage, rosemary, and
 thyme, chopped
2 medium limes
4 cloves garlic, chopped
¼ cup heavy cream
1 tablespoon flour
½ cup warm water
2 cups green grapes, sliced in half

Wash the hens with cold water and remove the giblets.
Wash and salt the cavity.
Put the hens in a roaster pan along with giblets.
Pour melted butter and wine over each hen.
Squeeze ½ lime over each hen.
Season each hen and sprinkle with chopped herbs.
Add chopped garlic to the giblets.
Roast for 1 hour, basting with the juices often.
As the hens begin to brown, cover with aluminum foil.
When the hens are done, remove them to a platter that can be
kept warm.
Pour cream into the pan and stir in with juices using a whisk.
Add flour and whisk so no lumps form to make a roux. Add water,
whisking.
Add grapes and stir in gravy until grapes are bright green.
Garnish platter with lime slices and herbs.
Pour gravy and grapes over hens and serve.

Menu Suggestions
Cream of Carrot Soup
Steamed asparagus
Rice pilaf
Sherbet Cake

Roast Duck

1 5–6 pound duck
½ cube unsalted butter, melted
¼ cup Chardonnay
Juice of 1 lime
1 onion, chopped
2 cloves of garlic, chopped
1 tablespoon each fresh thyme, sage and parsley
Salt and pepper

Preheat oven to 350 degrees.
Remove giblets and set aside.
Wash and salt duck cavity.
Put duck in a medium size roaster pan.
In a small saucepan, melt butter, add herbs and lime juice.
Pour over the duck and put in the oven to roast.
Put giblets, onion, and garlic in the pan and add about 2 cups water.
Cook duck for about 3 hours basting frequently.

Menu Suggestions
Butter Lettuce Salad with Light Lime Vinaigrette Dressing
Fresh tender green beans with butter
Mashed potatoes and gravy or brown rice
Kate's Raspberry Lime Pie
Cabernet Sauvignon or Chardonnay (we like Meridian), or mineral water with a slice of lime

Beef, Lamb, and Pork

"I am a great eater of beef, and I believe that does harm to my wit."

—*William Shakespeare*, Twelfth Night *I:3*

When many of us were growing up we were most interested in "getting to the meat of it" at mealtime, and that was literally what we meant. In the good old days, before we knew about cholesterol and relished being at the top of the food chain, beef, lamb, or pork was the main part—and highlight—of the meal.

Now we are being advised to cut back on the red meat in our diets. If you would like to ease your conscience a little bit about eating red meat, recognize that modern lean beef—not the highly marbled cuts of prime beef, but leaner grades of steak and roast—has no more (or only slightly more) cholesterol per ounce than chicken, pork, or lamb.

As noted in the *New Antoinette Pope School Cookbook*, the Council on Foods of the American Medical Association made the following statement: "Meat is especially noted for its protein, needed for the body building and repair, but it makes other valuable contributions to the balanced diet. It is rich in iron and phosphorus."

There are many ways to cook meat. Grilling will cook out much of the fat and can impart different flavors to the meat by using various woods (hickory, alder, oak, mesquite), charcoal, marinades, and sauces. Roasting enables us to cook many old favorites like leg of lamb, prime rib, or pork loin, to which we can add rich gravy made the old-fashioned way. Pot roasting uses less expensive cuts of meat—less marbled, tastier, but tougher cuts, that require longer simmering time to become tender. Frying is an old standby that retains more of the fat in the meat (and adds to that with fat in the pan), and is being replaced by many people with broiling.

I believe in moderation when it comes to health and diet, but sometimes my body seems to crave a big steak or some type of red meat—especially in the cooler days of fall and winter. Then I like to cook Louie's Short Ribs, Roasted Lamb Shanks, or Steak LCV.

Steak La Collina Verde

2½–3 inch porterhouse steak, seasoned with sea-
 soned salt and fresh ground pepper
2 tablespoons extra virgin olive oil
2 tablespoons butter
2 cloves garlic, chopped
Juice of 2 large limes
3 cups fresh mushrooms, sliced
2 tablespoons thyme, chopped
2 tablespoons parsley, chopped
2 bay leaves
¼–½ cup brandy
1 tablespoon fresh ground pepper
¼ cup Gorgonzola cheese
¼ cup half-and-half

In a medium-size saucepan, sauté garlic in butter and olive oil; add lime juice and stir for about 1 minute to blend.

Add herbs and mushrooms and sauté for 3–5 minutes.

Grind pepper into mixture and add bay leaves.

Add Gorgonzola cheese and half-and-half to mixture and stir to blend. Set aside.

Place steak on Weber grill and cook using the indirect method for 50 minutes for medium-rare.

Slice steak and place on a serving platter.

Remove bay leaf, reheat La Collina Verde Sauce and pour over steak, and serve.

Serves 4.

Menu Suggestions
Caesar Salad
Steamed broccoli
Fettuccine
Cabernet Sauvignon
Terrific Lime Cheesecake

Slavonic Steak

Besides being very tasty, this cut is economical and an absolutely superb left-over as a salad or hunter's breakfast. Pete and I had this steak in Kauai, and it was a refreshing change from "island" favorites. It took quite a bit of experimenting to get the ingredients just right.

1–2 pound flank steak
¼ cup extra virgin olive oil
¼ cup soy sauce
¼ cup red wine vinegar
Juice of 2 large limes
¼ cup red wine (Burgundy or Cabernet Sauvignon)
2 tablespoons Worcestershire sauce
1 tablespoon dry mustard
½ teaspoon seasoned salt
½ teaspoon garlic salt
Generous amount of fresh ground pepper
4 large cloves of garlic, chopped

Rinse flank steak with water, dry, and put in a large dish so you can turn and baste it easily.

In a bowl, mix dry mustard with red wine vinegar and wisk well. Add other ingredients and mix well.

Pour marinade over meat, cover, and refrigerate, basting and turning often. Or place meat in a heavy, large plastic bag, add marinade, and refrigerate, turning the bag several times.

Marinate at least 4 hours, or overnight.

This steak can be cooked several ways:
Barbecue or broil 4–5 minutes on each side for medium rare.
Leave steak in the marinade and roast at 350 degrees for 20–30 minutes.
Slice thin on the diagonal.

Menu Suggestions
Lime Vinaigrette Salad
Caryl's Roasted Potato Bake

Poor Man's Prime Rib

This is exactly the way that I cook prime rib, with the exception of the lime. Although this is an inexpensive cut of meat, the lime helps to tenderize the beef. The taste is much like prime rib and is great for tri tip sandwiches.

1½ pound tri tip (trimmed of some of the fat)
2 cloves garlic, chopped
1 teaspoon seasoned salt and garlic salt
Generous amount of fresh ground pepper
1 10½-ounce can of beef consommé soup (undiluted)
1 large lime

Preheat oven to 500 degrees.
Wash the tri tip with water and set in a small roasting pan.
Lace with garlic cloves.
Squeeze juice of lime over tri tip.
Season with salts and pepper.
Roast for 15 minutes.
Pour consommé over the tri tip.
Reduce heat to 350 degrees and cook for 30–45 minutes.
Baste often.
Slice thin and serve.

Louie's Short Ribs

This recipe belonged to my grandfather, Louis Joseph Seigel. When I took care of him during his bout with cancer he taught me how to cook short ribs and play the piano. This was a tough time of life for Louie, and I was amazed, as sick as he was, how much fun he could be. After dinner we "tinkered" at his baby grand piano, and I learned some interesting facts about his childhood in Cripple Creek, Colorado, and his newspaper-boy days at the Brown Palace in Denver. I like to serve Lime Vinaigrette Salad and a hearty bread with these ribs.

4–6 beef short ribs
2 large onions, 1 sliced, 1 quartered
4 cloves garlic, chopped
4 Russet potatoes, cubed
8 carrots, quartered
1 head of cabbage, sliced
½ cup soy sauce
½ cup hearty Burgundy
2 cups water
1 large lime
½ teaspoon seasoned salt
Dash of garlic salt and salt
Generous amount of fresh ground pepper

Preheat oven to 500 degrees.
Wash and dry short ribs.
Place sliced onion in the bottom of a roaster.
Lay short ribs over onions.
Sprinkle ribs with soy sauce, wine, and garlic.
Squeeze lime over ribs and season with salts and pepper.
Put short ribs in the oven and cook uncovered for 15 minutes.
Reduce heat to 350 and pour 1 cup of water over ribs.
Cook uncovered for 2 hours, basting often.
Add carrots, potatoes, and 1 cup water, and cook 30 minutes.
Add cabbage and chopped onions.
Baste, cover, and cook until done, about 30 minutes.

Carlton's Gourmet Lamb Chops

4 small loin lamb chops
3 cloves roasted garlic
1 tablespoon Worcestershire sauce
1 tablespoon red wine vinegar
1 tablespoon minced onion
Juice and grated rind of 1 lime
1 teaspoon each rosemary, sage, parsley, and thyme
2 teaspoons olive oil
Salt and pepper to taste

Combine marinade ingredients and pour over lamb chops.
Marinate overnight, or for at least 2 hours.
These chops can be broiled, baked or sautéed.

To roast garlic cloves:
Heat a small frying pan over medium heat.
Add unpeeled cloves and roast 10–15 minutes, turning every few minutes, until they are soft.
They will get some dark spots by the time they are roasted.
Take out of the pan, cool, and peel.

Roast Lamb with
Lime and Mint Jelly

6-pound boned and rolled leg of lamb
4 cloves garlic, chopped
3 tablespoons fresh rosemary, chopped
1 tablespoon olive oil
3 tablespoons mint jelly
1 large lime
Fresh parsley, stems removed

Wash and dry lamb roast.
Rub with olive oil.
Combine rosemary and garlic and rub over the roast.
Rub with mint jelly.
Squeeze lime over roast.

Preheat oven to 350 degrees.
Place roast in a roasting pan.
Cook 2½–3 hours for medium.
or
Prepare fire in Weber barbecue.
Cook indirect method for 1½–2¼ hours for medium.

Serve with mint jelly if desired.

Menu Suggestions
Summer Bruchetta
Caryl's Roasted Potatoes and Vegetables
Kiwi and Vanilla Pudding

Hawaiian Pork Chops

4 boneless pork chops, about 1 inch thick
1½ ounces rum
1 medium lime
Seasoned salt and garlic salt
Fresh ground pepper

Wash chops and pat dry with a paper towel.
Pour rum over chops.
Squeeze lime juice over each chop.
Marinate in the refrigerator for at least 4 hours. Best if marinated overnight.
Put chops on broiler pan.
Season lightly and broil for 6–8 minutes.
Turn, season other side, and broil for 6–8 minutes more.

Menu Suggestions
Fruit and Butter Lettuce Salad with Light Vinaigrette Dressing
Baked sweet potatoes
Brussels sprouts or nopales
Papaya Salsa
Strawberries and Kiwi in Gourmet Chocolate Sauce

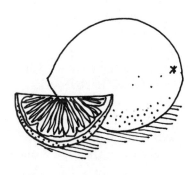

Sauerkraut and Spareribs

This recipe was passed down to me by my mother, who inherited it from my grandmother. The recipe originated in Alsace-Lorraine and came to America with my grandmother Laretta's father and mother. My great-grandfather Hanselman was a chef at the Broadmoor Hotel in Colorado Springs, and I often wondered if he prepared this dish for the guests. It doesn't look particularly appealing, but it is extraordinarily delicious. My mother gave me her recipe, much like the salad dressing recipe—a little of this and that, always certain to suggest the exact ingredients, but not the amount. After Mom passed away I was lonely for her and her home cooking and decided to take another chance at a family favorite. While I was outside pruning roses, that perfect smell wafted out the windows and doors, and I knew I had finally made sauerkraut and spareribs just like Mom.

2 racks pork baby back ribs
10 country-style pork ribs
1 4-pound jar sauerkraut
3 15-ounce cans tomato paste
3 15-ounce cans tomato sauce
2 large onions, chopped
6 cloves garlic, chopped
4 limes
½ teaspoon each seasoned salt, garlic salt
Generous amount of fresh ground pepper

Preheat oven to 450 degrees.
Wash ribs, dry and place on a rack in a large roaster.
Squeeze lime juice over all ribs.
Season with salt and pepper.
Cook ribs for 45 minutes.
Reduce heat to 375 degrees and cook for 1 hour.
Drain grease from roaster and remove rack.
Put ribs in the center of roaster.
Drain half of the sauerkraut juice from the jar.
Spread sauerkraut and remaining juice around ribs.
Put onion and garlic evenly on the top of sauerkraut.
Pour tomato sauce evenly on top of sauerkraut.
Put tomato paste as evenly as possible on top of sauerkraut.

Bake in oven at 350 degrees for 2 hours.
Season with more salt and pepper before serving, if desired.

Menu Suggestions
Lime Vinaigrette Salad
French bread and butter
Riesling Wine or Fischer Beer
Lime Shortbread Cookies

Baby Back Ribs with
Lime Zest Barbecue Sauce

4 racks of pork baby back ribs
Seasoned salt
Garlic salt
Fresh ground pepper
4 medium limes
Lime zest from 2 limes

Preheat oven to 500 degrees.
Wash racks of ribs, dry, and put, fat side up, in large roaster.
Squeeze 1 lime on each rack of ribs.
Chop lime zest into pieces and sprinkle over ribs.
Season with salts and pepper.
Cook ribs for 30 minutes.
Reduce heat to 375 degrees and cook for 30 minutes.
Turn ribs over and baste with Lime Zest Barbecue Sauce (see page 147), for 30 minutes, leaving some ribs without sauce for those who don't want ribs sauced.
Serve with a dish of additional sauce.

Elephant Stew

1 medium elephant
2 rabbits (optional)
1 bushel of limes
Salt and pepper to taste
Brown gravy

Cut elephant into bite size pieces (this should take about 2 months).

Add fresh squeezed limes, seasonings and enough brown gravy to cover.

Bake at 465 degrees for 4 weeks.

Serves 2,400 people.

If more people are expected, 2 rabbits can be added, but do this only if necessary, as most people don't like hare in their stew.

Marinades, Sauces, and Salsas

"Variety is the spice of life, that gives it all its flavor."
—*William Cowper,* The Task *(1784)*

D AVE Wilcox and Pete were college roommates until Dave married Betsy. As newlyweds, Betsy and Dave were on a shoestring budget. Cheap cuts of meat were affordable, but tough. They started experimenting and came up with a "secret" marinade. They later went into the restaurant business and started making their marinade. Allegro is now sold nationwide and internationally.

Marinades are combinations of herbs, spices, and liquids that flavor meat, chicken, fish, and vegetables. The lime is an especially useful ingredient because it contains an acid that helps yield a flavorful marinade and tenderize meat. Due to the acid content in marinades, it is best to use glass or ceramic dishes, rather than metal pots. Marinating overnight provides the best taste, and four hours is about the minimum time needed to effectively flavor the food. Most cooks are under the impression that a huge amount of marinade is needed for best results. Dave Wilcox suggests choosing a shallow pan about the same size as the food to be marinated and coating the bottom of the pan with a thin layer of marinade. That's sufficient, especially if you turn the food often.

The New Food Lover's Companion notes that the nineteenth-century French chef Antonin Carême is responsible for creating over a hundred sauces, all based on the five "mother sauces"—espagnole (brown stock based), velouté (light stock based), béchamel (basic white sauce), hollandaise and mayonnaise (emulsified sauces), and vinaigrette (oil and vinegar combinations). Making sauces was intimidating to me until I learned to make basic white sauce, which uses the same concept as making gravy (see the gravy recipe in Family Favorites). Using a whisk when making sauces always helps keep them smooth with good consistency. Adding lime to sauces requires constant whisking because the sauce and the lime juices can separate.

Dressings served cold must be mixed well, either in a blender, food processor, or jar with a tight lid. Dressings like vinaigrette, Roquefort, or bleu cheese are best made in advance to give the flavors of the ingredients a chance to blend. Hot dressings are what I consider "stuffings," usually made with a bread base. They are also tastier if mixed well—especially if using strong-tasting herbs like sage. Again, advance preparation seems to bring out the flavor in stuffings.

Lime Marinade

1 cup Cabernet Sauvignon
1 cup soy sauce
Juice of 2 limes
½ teaspoon garlic salt
½ teaspoon seasoned salt
½ teaspoon fresh ground pepper
4 cloves garlic, chopped
1 teaspoon each rosemary, thyme, oregano, and
 parsley

Combine all ingredients.
Use this marinade for beef.

If using marinade for poultry or fish, substitute a good white wine, such as one you would serve with the meal, in place of Cabernet Sauvignon.

If using marinade on tougher cuts of beef, add 1 tablespoon dry mustard to the marinade.

Marinades work best if used after at least 4 hours or, even better, overnight.

Quail or Chicken Marinade

This recipe was prepared for us when Carlton, head chef of Rancho San Carlos in Carmel, and his bride, Elisa, a gourmet pastry chef, came and visited. They shopped for the food, prepared and cooked one of the most elegant meals I have ever tasted—and cleaned up the entire kitchen. Pete and I felt like king and queen of the casa. After tasting this exquisitely prepared meal, I realized that I am a good cook but certainly not a gourmet cook. You will see a number of recipes throughout the book, which Carlton graciously shared.

1 teaspoon garlic, minced
1 tablespoon soy sauce
1 tablespoon Worcestershire sauce
1 tablespoon honey
Fresh ground pepper to taste
1 lime, juiced and skin grated
1 tablespoon olive oil
Fresh herbs of your choice

Mix together and marinate chicken or quail for at least 2–3 hours.

Ginger's Teriyaki Marinade

½ cup orange juice
½ cup olive oil
½ cup soy sauce
½ cup lime juice
2 tablespoons grated ginger

Mix all ingredients well.
Marinate meat at least 4 hours or, best, overnight.

This marinade is particularly good with chicken or less expensive cuts of steak.

Lime Vinaigrette Dressing

1 cup extra virgin olive oil
¼ cup red wine vinegar
Juice of 1 medium lime
½ teaspoon each, garlic salt and seasoned salt
Ground pepper to taste
1 tablespoon each, fresh basil, oregano, thyme,
 chopped
1 tablespoon each fresh cilantro, and parsley,
 chopped
¼ cup Parmesan cheese
¼ cup Gorgonzola cheese

You can make this dressing ahead of time.
Wash herbs. Set on a paper towel to dry.
Put all ingredients in a glass jar and refrigerate.
When ready to use shake well and pour over salad.

This is enough dressing for 3 large salads of 4 servings each. The
dressing will keep for one week, longer if you add cheeses separately.
Be sure to shake dressing well as it congeals when chilled.

Light Vinaigrette

This dressing is excellent with Fruit and Butter Lettuce Salad, Butter Lettuce and Watercress salad, Sea Bass and Fruit Compote, and Oven Fried Halibut with Lime Cilantro Butter.

1 cup extra virgin olive oil
¼ cup white wine vinegar
Juice of ½ medium lime
1 tablespoon fresh parsley
½ teaspoon seasoned salt and garlic salt
½ teaspoon fresh ground pepper
Dash of salt

Mix all ingredients together in a jar with a tight lid.
Shake well.
This will make enough salad dressing for 4 salads.

Carlton's Honey Balsamic Vinaigrette

4 tablespoons fresh-squeezed lime juice
½ cup balsamic vinegar
1 tablespoon honey
1 tablespoon dijon mustard
2 teaspoons red chili flakes
½ teaspoon garlic, chopped
1 tablespoon shallot, chopped
1½ cups olive oil
Salt and pepper to taste

Put all ingredients except oil in a blender or food processor.
Slowly add olive oil and blend until emulsified, about 2–3 minutes.
Makes about 2½ cups of dressing.

Mustard Vinaigrette

This is delicious with spinach salad.

½ cup extra virgin olive oil
1 teaspoon dry mustard
2 tablespoons red wine vinegar
Juice of 1 medium lime
½ teaspoon seasoned salt
½ teaspoon garlic salt
Fresh ground pepper

In a jar with a tight lid, blend dry mustard into red wine vinegar.
Add other ingredients and shake well.
Chill before serving.

Lime Hollandaise Sauce

3 egg yolks
1 tablespoon fresh lime juice
½ cup melted butter
¼–½ tablespoon Wondra flour

In a saucepan, melt butter over low heat.
Add egg yolks, whisking slowly and constantly.
Gradually add the lime juice, continuing to whisk slowly.
Gradually add the flour, continuing to whisk slowly.
Bring to a slow boil, stirring well for about 5 minutes.
Serve immediately.
If sauce starts to curdle, add a small amount of hot water, and
whisk.

La Collina Verde Sauce

2 tablespoons virgin olive oil
2 tablespoons butter
2 cloves garlic, chopped
Juice of 2 large limes
3 cups fresh mushrooms, sliced
2 tablespoons each fresh parsley and thyme, chopped
2 bay leaves
¼–½ cup brandy
1 tablespoon fresh ground pepper
¼ cup Gorgonzola cheese
¼ cup half-and-half

In a medium-size saucepan, sauté garlic in butter and olive oil, add lime juice, and stir for about 1 minute to blend.

Add herbs and mushrooms and sauté for 3–5 minutes.

Grind pepper into mixture and add bay leaves.

Add Gorgonzola cheese and half-and-half to mixture and stir to blend. Set aside.

Just before serving on steak or beef, remove bay leaf and reheat.

Lime Zest Barbecue Sauce

1 28-ounce bottle of ketchup
2 medium limes and zest from the limes
1 large onion, chopped
2 cloves garlic, chopped
2 tablespoons dark brown sugar
1 teaspoon Tabasco sauce
2 tablespoons butter

Sauté onion and garlic in butter.
Add ketchup.
Squeeze juice of both limes into sauce mixture.
Add zest and bring to slow boil.
Gradually add brown sugar, stirring constantly.
Add Tabasco sauce.
Bring all ingredients to slow boil and simmer for 45 minutes, stirring often.
Serve over baby back ribs, country-style ribs, or with broiled or barbecued chicken.

Papaya Salsa

1 large papaya, peeled and chopped into bite-size
 pieces
2 red onions, chopped
¼ cup cilantro, chopped
1 avocado, peeled and chopped into bite-size pieces
1 clove garlic, chopped
Juice of 1 lime
¼ teaspoon salt
¼ teaspoon ground cumin

Put first five ingredients in a medium-size mixing bowl. Add lime juice and seasonings.

Mix well and serve with fish or chicken.

Sheri's Quick Hot Salsa Verde

My sister's specialty is Mexican cooking. She makes tasty enchiladas, chicken mole, and huevos rancheros, as well as this green chile sauce. In addition to her specialties, she makes great ham and beans and, best of all, she makes vegetable soup just like our mother's. I make the chicken soup, and she makes the vegetable. If we get hungry for home cooking, we can cook "Mom's best" for each other.

1 15-ounce can tomatillos
1 6-ounce can green chiles
1 6-ounce can jalapeño chiles
Garlic salt and oregano to taste
Juice of ½ lime

Put all ingredients into a blender or food processor and blend well.

Serve chilled with tortilla chips.

Pico de Gallo

Pico de gallo translates to "beak of the rooster."

2 tomatoes, chopped
1 onion, chopped
¼ cup cilantro, chopped
Juice of 1 large lime
2 jalapeño chiles, seeds removed, chopped

Combine all ingredients and mix well.

This salsa is quite hot and is good served along with green salsa and red salsa. This can be served with any Mexican food.

Irmal's Salsa Fresca

This salsa is excellent with Lime Snapper Vera Cruz or served with tortilla chips.

2 medium tomatoes
2 jalapeño chiles
3 green onions
½ cup cilantro
1 tablespoon lime juice
Optional:
 Pepper and salt
 Pinch of cumin

Chop all the vegetables.
Mix together in a bowl.
Add seasonings and lime juice.

Honey Lime Butter

1 cube (½ cup) butter, softened
½ cup honey
1 medium lime

Mix honey and butter together. Gradually squeeze in juice of 1 lime. Mix well.
Serve with English muffins, fresh baked bread, or croissants.

Cilantro Butter

½ cube (¼ cup) butter, softened
1 tablespoon cilantro
1 medium lime

Wash cilantro and limes and set on paper towel.
Chop cilantro.
Add the cilantro to the softened butter and blend.
Gradually squeeze the juice of 1 lime into the butter as you blend.
If there is any lime juice that isn't incorporated into the butter, pour it out.
Serve on fish or chicken.

Lime Butter

1 cube (½ cup) butter
Juice of 1 large lime

In a small saucepan, melt butter.
Gradually add lime juice.
Excellent with lobster or crab.
Experiment by adding garlic or your favorite herbs.

Desserts

"Seize the moment. Remember all those women on the Titanic who waved off the dessert cart."

—*Erma Bombeck*

D ESSERTS are my weakness in two ways. One is that I love them, the other is that I am not a good dessert cook. My repertoire of desserts is limited, so friends and family have contributed most of the recipes in this chapter.

Dessert, like any part of the meal, can be plain-vanilla simple or a work of art. Dessert should complement the meal, just as all courses of the meal should be compatible. Desserts delight the eye as well as the palate—that's why it is always so hard to make a selection from the dessert cart at a restaurant. Desserts are beautiful, colorful, and delectable.

When making desserts allow plenty of time. Check your oven temperature to make sure it is accurate. *Read the directions!* Following the recipe is especially important when baking. I once made a chocolate cake with silver balls on the top. Dear Uncle Bill ate his entire piece, even though I misread the recipe and added baking soda instead of baking powder. Remember the angel food cake story? The cake never rose and was half an inch thick because the wrong ingredients had been used. When making desserts, as with cooking in general, I put the ingredients to be used on the left side of the counter and the ones already used on the right. Devising a system for keeping track helps.

Desserts are fun once you get the hang of it. They make nice gifts during the holidays, and are an appreciated dish for a potluck or casual get together. Desserts are meant to be savored and enjoyed. *Bon appetit!*

Lime Granita

Besides being a delicious light dessert, this ice is great for cleansing the palate between courses.

2 cups water
½ cup sugar
Zest of 2 limes
Juice of 2 limes

In a saucepan bring water and lime zest to a boil.
Add lime juice and mix well.
Strain the mixture.
Pour into a "freeze-proof bowl" and freeze for 2 hours or more until it is the consistency of a slush.
Spoon into chilled wine or champagne glasses and serve.

Gourmet Chocolate Sauce

Use gourmet chocolate sauce for ice cream sundaes, strawberries, and kiwis. Drizzle on lime custard and on graham crackers—it's wonderful on just about anything.

 1 package Hershey's Semi-Sweet Morsels
 ½ lime
 ⅔ cup heavy whipping cream
 1 ounce brandy

Heat chocolate in a saucepan over low heat.
Stir until melted.
Squeeze lime juice into chocolate.
The chocolate will seize (become hard and clumpy). Don't panic.
Gradually stir in cream until chocolate becomes creamy again.
Add brandy slowly and stir.

Ginger and Lime Crème Brulée

6 egg yolks
1 cup heavy whipping cream
2 tablespoons fresh ginger, chopped fine
2 tablespoons granulated sugar
4 tablespoons dark brown sugar
Juice of ½ lime

Preheat oven to 375 degrees.

Separate eggs and put yolks in a saucepan.

Add cream and heat over low to medium-low heat, stirring constantly until well mixed.

Do not bring to a boil.

Add granulated sugar and stir until dissolved.

Add chopped ginger.

Pour into 4 individual custard cups.

Set custard cups in a pan of warm water.

Cook for 30 minutes or until toothpick, when inserted, comes out clean.

While Crème Brulée is cooking mix brown sugar and lime juice.

Remove pan and pour sugar and lime mixture over the top of each cup.

Use cooking torch for 2 minutes on each or broil until sugar and lime mixture melts and hardens.

Refrigerate until ready to serve.

When ready to serve garnish with lime flowers or johnny jump-ups or both.

Lime Baked Custard

At the new Getty Museum restaurant I ordered lime custard, and it was served with chocolate sorbet and raspberry sauce. This is an absolutely delicious combination of sweets. If you are looking for a dessert to serve to a connoisseur for a festive occasion, this is a fine selection.

3 eggs, slightly beaten
⅓ cup sugar
Juice of 1 medium lime
Dash of salt
2½ cups milk, scalded
Ground nutmeg
Ground ginger

Preheat oven to 350 degrees.
Mix eggs, sugar, lime juice, and salt.
Gradually stir in scalded milk.
Pour into medium-size bowl.
Sprinkle ground nutmeg and ginger over the custard.
Pour hot water into a large baking pan and set custard in the middle of pan.
Bake for 1 hour or until knife comes out clean.
Serve well chilled.
Just before serving garnish with thin lime slices and blue pansies.

Lime Flower Cake

2 cups flour
½ cup sugar
3½ teaspoons baking powder
1 teaspoon salt
3 eggs
½ cube (¼ cup) butter, softened
1 cup milk
Juice of 1 medium lime

Preheat oven to 350 degrees.
In a large bowl mix dry ingredients together.
In a separate bowl cream the eggs and butter.
Add lime juice and milk to the egg mixture and blend well.
Add the egg mixture to the dry ingredients and beat until well blended.
Grease and flour 2 9-inch round cake pans.
Pour half the batter into each pan.
Drop cake pans on the counter until air bubbles pop.
Bake for 30–35 minutes or until a toothpick comes out clean.
Cool.

Lime Frosting
1 pound powdered sugar
1 cube (½ cup) melted butter
Juice of 1 medium lime

Mix all ingredients together until smooth.
Remove the layers from the pans and put frosting on bottom layer as filling.
Add top layer and frost top and sides using upward strokes.
Decorate with lime flowers and pansies. If you don't have fresh flowers, you can purchase them in the produce section of a specialty market.

Kate's Raspberry Lime Pie

Santa Barbara is blessed with the best adult education program I have ever had the privilege of attending. Both Pete and I take as many classes as we can, and Pete attends a woodcarving class taught by Rica Colter. Rica likes to host two potlucks a year for her students. One day Pete returned from her potluck and raved about a pie he tried. He asked Kate for her recipe, and she sent it right away!

When I called Kate to ask permission to use this recipe in my book, as well as make the substitution of lime for lemon, I asked her where she found it. She just made it up! Kate likes to cook with low-fat ingredients. Substitute eggs, whipping cream, regular caramel syrup, and condensed milk if you want the high-calorie version.

½ cup egg substitute
1 14-ounce can nonfat, sweetened condensed milk
½ cup lime juice
1 9-inch pie crust
1 8-ounce container Cool Whip
2 baskets fresh raspberries
1 apple, chopped
¼ cup sugar
4 tablespoons cornstarch
¼ cup non-fat caramel syrup

Preheat oven to 325 degrees.
Beat egg yolks, milk, and lime juice until well blended.
Pour mixture into the pie crust and bake for 30 minutes.
In a saucepan combine raspberries, apple, carmel, cornstarch, and sugar.
Cook and stir over medium-high heat until the mixture thickens.
Remove from heat and allow to cool.
Spoon fruit mixture into the pie crust.
Chill for at least 4 hours.
Top with Cool Whip and serve.

You can substitute strawberries and garnish with toasted coconut.
You can also substitute sugar for caramel syrup.

Menu Suggestions
On Father's Day Pete requested:
Crab Dip and Artichoke Tapenade
Lime Vinaigrette Salad
Baked Stuffed Potatoes
Barbecued tri tip
Baked Zucchini
Kate's Raspberry Lime Pie

Liliane's Lime Chantilly Pie

This recipe was generously submitted to me by Mary Jane Chilton, who was given this recipe by Liliane Smith, both neighbors of La Collina Verde. Mary Jane had heard through the neighborhood that it was okay to pick limes at LCV, and came to the door to see if this was true. We had a nice chat about limes and recipes. I asked Mary Jane if she had any dessert recipes she would be willing to share with me. This is one that she raved about, and it is luscious.

1 cup sugar
1½ cups water
2 tablespoons butter
⅓ cup cornstarch
Juice and grated rind of 4 limes
¼ teaspoon salt
4 egg yolks
3 tablespoons milk
1 9-inch baked pastry shell

In a saucepan combine sugar, 1 cup water, and butter and heat until sugar is dissolved.

Add cornstarch blended with ½ cup cold water and cook, stirring until clear (about 8 minutes).

Add the egg yolks beaten with the milk and bring to boiling point stirring constantly.

Remove from heat and immediately add lime juice and grated peel and stir well.

Allow to cool and pour into baked pie shell.

Top with Chantilly Cream and refrigerate until ready to serve.

Chantilly Cream
Whip 1 pint heavy cream in a chilled medium mixing bowl.
Add 8 ounces sour cream and blend.
Add ½ teaspoon vanilla and blend again.

Santa Barbara Lime Pie

1½ cups chocolate graham crackers
⅓ cup melted butter
3 large eggs, separated, kept at room temperature
14-ounce can sweetened condensed milk
Juice of 3 large limes
¼ cup sugar

Preheat oven to 350 degrees
For the crust:
Roll the graham crackers with a rolling pin until well crumbled.
Place in a bowl.
Add butter and mix together.
Press mixture into a 9-inch glass pie pan starting at the bottom
and pressing well into the sides.
Bake for 10 minutes and cool.

For the Filling
In a large bowl beat the egg yolks with condensed milk.
Stir in the lime juice, a little at a time. Stir well.
Spoon the filling into the shell.
Chill the pie for 1 hour.

For the Meringue
Beat the egg whites in a chilled bowl.
Add a pinch of salt and beat until the whites hold soft peaks.
Add sugar slowly and beat until the meringue holds stiff peaks.
Use a spatula and spread the meringue over the lime filling.
Bake for 15 minutes or until meringue is golden.
Chill the pie for about 2 hours.
Garnish with lime slices and lime flowers.

Cheri's Terrific Lime Cheesecake

This is Cheri's Hollywood Cheesecake recipe, and the best I have ever tasted. I changed the recipe by adding lime and find this adds a refreshing taste to the cheesecake.

Crust:

 1⅓ cup graham crackers, crushed fine
 ¼ cup finely chopped walnuts
 ½ teaspoon cinnamon
 ½ cup melted butter

Combine ingredients.
Press crust mixture into 9-inch spring form pan pushing partially up side of pan, reserving 3 tablespoons of the mixture.

Filling:

 3 well-beaten eggs
 2 8-ounce packages softened cream cheese
 1 cup sugar
 ¼ teaspoon salt
 ½ teaspoon vanilla
 3 teaspoons lime juice
 3 cups sour cream

Combine all ingredients except sour cream, beat smooth.
Blend in sour cream and pour into crust.
Trim with reserved crumb mixture.
I like to garnish with sliced kiwi and borage flowers.

Lime Shortbread Cookies

¾ cup butter, softened
¼ cup granulated sugar
2 cups flour
1 medium lime
Powdered sugar

Preheat oven to 350 degrees.
Mix butter and granulated sugar together.
Squeeze juice of lime into mixture and mix until incorporated.
Add flour gradually. If necessary add 1–2 tablespoons melted butter to form a dough ball.
Lightly flour pastry board or countertop.
Roll dough ½ inch thick and cut into desired shapes.
Place cookies on ungreased cookie sheet.
Bake about 20 minutes or until a light golden color.
Remove from cookie sheet.
Dust lightly with powdered sugar.

Summer Peach Cobbler

I learned from my friend Sue Mills that "hill people" from the south like their cobbler served different ways. So I decided to check out this theory and, sure enough, people I asked all had different opinions. Pete likes his cobbler hot with nothing on top, Sue likes hers hot in a custard dish with cream poured over. Bruce Van Dyke likes his hot with whipped cream, and I like mine hot with French vanilla ice cream. Whatever you put on the top, enjoy this summer treat.

Filling
 5 cups fresh peaches, peeled and sliced
 1 lime
 ¼ cup sugar
 1 tablespoon cornstarch
 ¼ teaspoon ground cinnamon

Wash and slice peaches and squeeze lime juice over all to keep them from turning dark.

In a small bowl, mix sugar, cinnamon, and cornstarch together.

In a medium saucepan, heat peaches and dry mixture over low heat.

Bring to a boil and cook for 5 minutes.

Pour mixture into an ungreased 1-quart casserole dish.

For the crust
 1 cup flour
 ¾ teaspoon sugar
 1½ teaspoons baking powder
 ½ teaspoon salt
 3 tablespoons butter
 ½ cup milk

Preheat oven to 400 degrees.

In a medium bowl, mix flour, sugar, baking powder, and salt.

With a knife, cut butter into the dry mixture until pea-size crumbles form.

Add milk and stir until blended and a dough forms.

Drop about 9 or 10 tablespoons of dough on top of the peach mixture.

Bake for 30 minutes.

Serve piping hot with French vanilla ice cream (or...?).

Aunt Sharon's Sherbet Cake

1 pint orange sherbet
1 pint lime sherbet
1 pint lemon sherbet
1 pint heavy whipping cream, whipped
1 package Mother's coconut cookies

Remove one of the pints of sherbet from the freezer so it can soften.

Crush cookies (about 16) between two pieces of waxed paper, using a rolling pin.

Place crumbs in the bottom of a spring-form pan, reserving a third.

Top crumbs with the softened sherbet, making an even layer.

Make a thin layer of whipped cream on top of the sherbet.

Place in the freezer to harden, about 2 hours.

Follow the same routine for the other two pints of sherbet, layering whipped cream between each.

Place the reserved crumbs on top.

Return to freezer and leave overnight or longer.

Remove from cake pan before serving.

Cut the cake in thin slices, about 1½ inches, for a very pretty party dessert.

Family Favorites

"When we eat and enjoy the incredible taste of food, we should remember that it is God who has given food the qualities we enjoy. In this understanding we will serve God by eating."

—*Ba'al Shem Tov*

WHILE traveling through the Bavarian Alps in Switzerland, my husband, Pete, and I discovered a resort that was used by BMW employees and their families for vacationing. The inn was luxurious, and the dining room was spacious and hospitable. At dinner our first evening I noticed "Grandma's Favorites" on the menu. We talked with the innkeeper about the menu, and he told us that these were his grandmother's recipes. He said that such recipes were becoming more difficult to find, and he wanted these recipes preserved and shared with family and travelers at the inn.

The idea to include family favorites in *A Squeeze of Lime* came from that innkeeper. I wanted these recipes from our family heritage to be preserved and passed from generation to generation. I use lime in almost every recipe and certainly every day, but I use lime in only a selected few family favorites. It would be a shame to change a family heirloom (perfect as is), and this is how I think of these recipes, so I present them here as they came to me.

Family gatherings were an important part of my life. Food was a positive, nurturing part of sharing holidays. Special occasions, picnics, barbecues, family reunions, and Sunday dinners were treated with as much importance as holidays. Birthdays were extra special because the birthday person selected his/her favorite dishes.

Holiday menus were traditional and predictable: New Year's Day was cassoulet with lucky beans; St. Patrick's Day brought corned beef and cabbage; Easter was ham and scalloped potatoes; Mother's Day meant roast chicken; Father's Day was barbecued steak and stuffed baked potatoes. On Thanksgiving we ate turkey with all the trimmings, and on Christmas Eve we had creamed tuna in a chafing dish and "snow balls," (vanilla ice cream rolled in coconut with a red or green candle) and we always celebrated Christmas with prime rib, a perfect finale for the year.

One of my favorite pastimes is perusing cooking magazines, food sections in newspapers, and cookbooks to look for new recipes with which to experiment. During the holidays I tend to fall back on family favorites. There is something reassuring about cooking tried-and-true recipes that family and friends expect and enjoy.

Merle's Roasted Garlic Appetizer

Merle has worked and studied in the culinary field, and when she visits she cooks her new discoveries for us. This was one.

Neatly trim bottom of 2 bulbs of garlic.

Trim excess skin from tops.

Drizzle with olive oil.

Grind salt on top (optional).

Roast at 350 degrees for 30 minutes. Time may vary from 15 minutes to 45 minutes.

The cloves should just be popping from their skins and golden in color when ready.

Serve with lightly toasted rounds of Italian or French bread.

Cream of Mushroom Soup

2½ cups mushrooms, washed, dried, and sliced thin
4 tablespoons butter
3 tablespoons flour
1 cup milk
1 cup chicken broth
1 white onion, chopped
½ teaspoon seasoned salt
½ teaspoon fresh ground pepper
Fresh parsley, stems removed

In a 2-quart sauce pan sauté onion in butter until golden.
Add mushrooms and sauté.
Blend in flour, a little at a time, until creamy.
Add seasoned salt and pepper.
Add milk gradually.
Add chicken broth and bring to a boil, stirring constantly.
Turn heat down to low and keep stirring, as milk scalds easily, for 30 minutes.
Serve hot and sprinkled with fresh parsley.

Menu Suggestions
This soup is filling and can be served as a complete meal for two with a small spinach salad, fresh bread, and the beverage of your choice.
or
Cup of Mushroom Soup
LCV Salmon or sea bass
Asparagus
Lime custard with chocolate sorbet and raspberry sauces.
Fumé Blanc

Sheri's Vegetable Soup

This is a fourth-generation recipe handed down from my grandmother (Ganny) to my mother, to my sister and me, and now to my daughter. Each of us varies the recipe just a little. I remember Mother using oxtails to add richness to the broth.

2 quarts water
2 large beef shanks
1 onion, sliced
2 cloves garlic, chopped
3 stalks celery, sliced
3 carrots, peeled and sliced
3 potatoes, peeled and sliced
1 28-ounce can stewed tomatoes
1 package frozen vegetables with lima beans and
 corn
Pinch basil
1 bay leaf
Salt and pepper to taste

To a soup pot add water, beef shanks, onion, garlic, celery, and bay leaf.

Bring to a boil, reduce heat, and simmer for about 2 hours, or until the meat is almost tender.

Add tomatoes and frozen vegetables.

Bring to a boil, season, and simmer for about 15 minutes.

Remove bay leaf before serving.

Bertha's German Potato Salad

6 medium russet potatoes
⅓ cup red wine vinegar
¼ cup sugar
1 tablespoon cornstarch
2 slices bacon, cooked and crumbled
½ small white onion
Salt, pepper and chopped parsley to taste

Cook potatoes, rinse, chill, and peel.
Grate onion and set aside.
Slice potatoes into thin slices and place in a serving bowl.
Cook bacon and save drippings in pan.
Add grated onion and chopped bacon to the bowl.

Make the dressing:
In a bowl mix the vinegar and sugar.
Mix the cornstarch with 1 cup water and add to vinegar mixture.
Pour into frying pan with heated bacon drippings.
Cook over medium heat until thickened, stirring constantly, about
15 minutes.
Add hot dressing to potatoes, onion and bacon.
Add salt, pepper, and parsley and mix carefully.
Chill for several hours before serving.

Menu Suggestions
Serve with bratwurst, sauerkraut, and a hearty bread.
German beer or Rhine wine.

Betty Jo's Potato Salad

This potato salad is my mother's recipe which was at every family reunion that I can remember. If mother didn't make it, you can be sure my grandmother would bring it. This salad is always good with burgers, hot dogs, and barbecued food.

6–8 large russet potatoes
4 stalks celery, chopped
2 red onions, chopped
4 hard boiled eggs, sliced
1 cup mayonnaise
½ cup Grey Poupon mustard
¼ cup red wine vinegar
1 teaspoon seasoned salt
1 teaspoon fresh ground pepper
3 tablespoons fresh chopped parsley, saving some for
 garnish
Paprika (optional)

Wash and boil potatoes for 40 minutes. Make sure the potatoes are firm and not mushy. Cool. Potatoes are easy to peel this way if you like.

Wash other vegetables while potatoes are cooling.

Hard boil eggs and refrigerate.

Mix mayo, mustard, vinegar, and seasonings in a large bowl. Taste and add more seasoning if necessary.

Cut potato in slices, add celery, onions and 2 eggs to dressing mixture.

Put potato salad in a large serving bowl.

Garnish with remaining egg slices, and parsley.

Sprinkle with paprika.

Bertha's Sweet and
Sour String Beans

This is Pete's mother's recipe, which is often served with the Thanksgiving feast at the Petersons'. We have had great fun with this recipe because we made a whole day of collecting unusual gadgets in a hardware store in San Francisco's Chinatown. We have asked several good sports who were visiting us to use "this gadget" to French cut the beans. They of course think we are nuts because frozen French beans work quite well.

 1 pound green beans, French sliced (use French bean
 slicer found in gourmet cooking stores)
 1–2 slices bacon
 ¼ onion, chopped
 ¼ cup sugar
 ¼ cup red wine vinegar
 About ½ cup of cooking water from beans

Wash beans and pat dry.
Steam for about 20 minutes.
Drain water reserving ½ cup, and put beans into vegetable bowl.
Cook bacon till crisp, drain and slice in pieces.
Fry onion in bacon drippings.
Add vinegar and reserved vegetable water to the pan and mix until sugar dissolves.
Pour dressing over beans and mix well.
Add dash of pepper and serve.

Aunt Sharon's Copper Pennies

This is the recipe that Aunt Sharon is most noted for. Everyone always asks her to bring her copper pennies to family reunions, picnics, baby or bridal showers. She generously brings extra for family to take home as well as the baggies to put them in (we always tease her about being so organized). Rumor has it that Sharon has everything in her kitchen alphabetized.

2 pounds carrots
1 small green pepper, thinly sliced
1 medium onion, thinly sliced
1 10½-ounce can tomato soup
½ cup olive oil
1 cup cider vinegar
1 teaspoon prepared mustard
1 teaspoon Worcestershire sauce
1 teaspoon salt
1 teaspoon pepper
1 cup sugar

Peel carrots, slice, and cook in small amount of water until tender (I steam them). Drain.

Combine soup, oil, sugar, vinegar, mustard, Worcestershire sauce, salt, and pepper, and cook until sugar is melted.

Place onion and green pepper in hot sauce.

When sauce has cooled a little (about 10 minutes), pour over carrots and stir.

Place in refrigerator.

May be kept for many days, and they freeze well.

Any leftover sauce makes a good French dressing.

Helen's Pink Beans

This recipe was given to me by Helen Lawrence. I associate the recipe with fond memories of Jennifer, our daughter, and Michael Lawrence's wedding. When Jennifer and Mike were planning their wedding reception, they were determined not to have the standard fare. They decided to have a Portuguese feast to honor Mike's side of the family, and my mother's potato salad because, "Grandma couldn't be with us." To honor the French side of the family, the dessert was croquembouche. We now serve this menu on Christmas Eve, honoring the birthday of our son-in-law, Michael, on Christmas and the birthday of our grandson, Jeffrey, on Christmas Eve.

2 pounds pink beans
¼ cup vegetable oil
1 large onion, chopped
1 head garlic, cloves chopped or pressed
16 ounces tomato sauce
½ tablespoon pepper
2 tablespoons cumin seed

Soak the beans overnight in water to cover.
Drain and rinse beans. Set aside.
Sauté onion in a large pot.
Add other ingredients and water to cover.
Cook over low heat for 4 hours, stirring occasionally.
If prepared in advance (and these beans are best the next day), heat 30 minutes before serving.

Menu Suggestions
Betty Jo's Potato Salad
Linguisa
Croquembouche

Caryl's Red Potato Bake

4 red potatoes, halved or quartered
1 onion, roughly chopped
1 green pepper, roughly chopped
1 red pepper, roughly chopped
2 garlic cloves, minced
¼–½ cup olive oil

Preheat oven to 400 degrees.

Place vegetables, not including the garlic, in a plastic bag with the oil.

Shake well.

Pour vegetables in a casserole dish, mix in garlic, and cover tightly with aluminum foil.

Bake for 50 minutes.

Stuffed Baked Potatoes

This is a great fix-ahead recipe for casual entertaining. These potatoes freeze well in zip-lock bags. My grandchildren love these potatoes—they make a nutritious snack.

4 large russet potatoes, Idaho if you can find them
1 cup milk
2 teaspoons seasoned salt
2 teaspoons fresh ground pepper
Dash salt
½ cup sour cream
¼ cup chives, chopped
¼ cup parsley, chopped
4 slices cheddar cheese

Preheat oven to 400 degrees
Wash and dry potatoes and cook for 1 hour.
Cool.
Reduce oven heat to 350 degrees.
Mix all ingredients, except cheddar cheese, in a mixing bowl.
Cut cool potatoes in half lengthwise.
Scoop out potato, being careful not to break the shells.
Add potato to the mixing bowl with the other ingredients.
Using an electric mixer, mix on medium high until smooth.
Stuff the potato shells with the potato mixture.
Add cheddar cheese.
Bake for about 30 minutes.

Menu Suggestions
Simple Green Salad
Meat Loaf
Broccoli

Scalloped Potatoes

6–8 Yukon gold potatoes, peeled and thinly sliced
(place in a bowl with water to cover so they don't
brown)
4 tablespoons butter
3¼ cup flour
1 cup milk
2 bunches green onions, washed and sliced using the
tops
2 cups cheddar cheese, grated
Salt and pepper

Preheat oven to 400 degrees.
Make a white sauce:
In a saucepan melt butter over low heat.
Stir flour into the butter slowly using a whisk so that the mixture
isn't lumpy.
Add milk slowly, stirring constantly, until well blended.
Cook over low heat until the sauce thickens.
Season with salt and pepper.
Rub a large casserole dish with olive oil.
Drain potatoes and pat dry.
Make a layer of potatoes, add some white sauce, sprinkle with
green onions, grated cheese, salt, and pepper.
Repeat until all the ingredients are used, adding a final layer of
white sauce and cheese on top.
Bake for 30 minutes covered, reduce heat to 350 degrees and bake
for 1½ hours.

Bertha's Turkey Dressing

This dressing recipe is Pete's mother's. Bertha used to make this with roast chicken for Pete's dad, Jerry's, birthday. This is a cherished recipe, and has been passed down through the family. When we call each other to wish a happy Thanksgiving, one question that's always asked is, "Is your oyster stuffing in?"

2 small loaves white bread, a few days old if possible
2 small jars raw oysters
2 white onions, chopped
6 stalks of celery, chopped
3–4 eggs, beaten
2 tablespoons butter
½ teaspoon salt
½ teaspoon pepper
¼ teaspoon nutmeg
2 tablespoons parsley, chopped

Preheat oven to 350 degrees.

Sauté celery and onion in butter until just limp.

Cut bread into about 5 pieces; soak in water a few minutes.

Squeeze out as much water as you can and place in large mixing bowl.

Add onions and celery to the bread.

Add eggs, oysters, salt, pepper, nutmeg and parsley to bread mixture.

Put in a casserole and bake 30–45 minutes.

Menu Suggestions
Traditional Thanksgiving dinner
Excellent with roast chicken or pork

Fettuccine

When my daughter, Jennifer, was away at college she called and said, "Mom, I'm out of money." She had $5.63 to last until Monday. There was a slight pause, and I said, "Do you have Grandma's ingredients to make salad dressing, a tomato, a can of tuna, and Fettuccine noodles?" She put down the phone and came back sounding kind of down, "Everything except the noodles and tomato." "Well, aren't you lucky. Noodles are very cheap and very filling, and you don't like tomatoes anyway. Why don't you make a Fettuccine with tuna tonight and tomorrow make a cold pasta salad with Grandma's dressing? I'll call you over the weekend to see how you are." All weekend long I wondered if I should wire her money. Should I fly up and cook her a home-cooked meal? On Sunday evening we talked and Jennifer said, "Mom, I made the best pasta salad, just like Grandma, and I still have $2.50 left."

> 1 pound fettuccine (I like De Cecco brand from Italy)
> ¾ cup milk
> ¾ cup butter
> ½–¾ cup grated Parmesan cheese
> ½ teaspoon seasoned salt
> Fresh ground pepper
> Fresh parsley, chopped

Cook the noodles according to the directions on the package.
Drain noodles in a colander.
Put noodles in large pasta bowl.
Melt butter in saucepan.
Add milk to warm.
Add seasoned salt and pepper and pour over pasta.
Sprinkle with parsley.
Add Parmesan cheese and toss until noodles are well coated.

These noodles, leftover, make an excellent salmon, calimari, chicken, or beef pasta salad.

Gravy

There are two basic ways to make gravy, and the determining factor is whether there has been water added to the dish during the cooking (i.e. pot roast or sauerbraten). The secret to good gravy is to take your time, keep stirring, and be patient.

Method 1: If there has been no water added

Stir or whisk flour into drippings slowly (start with 1 or 2 tablespoons unless there is a large amount of drippings) over medium-low heat until it thickens.

Add water or broth and keep stirring gently on low heat (bring to low, low boil and back off) until gravy is desired thickness. Do this by adding more water than you need in small increments and reducing it. Potato water will enhance the flavor, and we generally use Lawry's seasoned salt and pepper to taste.

This method works with any kind of fat—pan drippings for gravy, butter and milk for a white sauce, or drippings and milk for a white gravy.

Once you add the water, if you need more flour, you have to go to Method 2.

Method 2: If the meat has been cooked with water added

Shake a couple of tablespoons of flour in a bottle with water to mix them together before adding to the drippings—otherwise you get little dumplings (lumpy gravy). Add to juice and drippings.

From this point continue as above by adding water or broth as desired, reducing, and seasoning.

Neither method is hard, it just takes a couple of times to get the feel. Pay attention to the gravy, keep stirring slowly (I use a wooden spoon) and be patient—it's worth it.

Pete's Squid

Cleaning squid takes just a little effort but is well worth it. Most of the squid that we have bought pre-cleaned really needed to be gone over, which is as much work as doing it right from the beginning. This system works well.

1. Cut off the tentacles just above the eye and set aside.

2. Squeeze the beak out of the tentacles—it's like a garbanzo bean. Discard the beak.

3. Open the body full length down one side and remove the innards, making sure to pull out the transparent quill, and discard this with the rest of the innards.

4. Rinse the body and tentacles well, and you are ready to go. We cut the body crosswise in strips about 1½ inches long.

There are many ways to cook squid, but our favorite is to sauté it in olive oil, which only takes a few minutes. If you wish to add garlic, mince it and sauté in the olive oil until lightly browned prior to cooking the squid (both body and tentacles go in together).

What makes this worth the work of cleaning is that we get two meals that we especially like with this squid.

Meal one
Cook bountiful amounts of squid, fettuccine with a sauce of butter and half-and-half, and steamed broccoli.

Meal two
After finishing the first meal we mix the squid, fettuccine, and broccoli together, cover and refrigerate.

When ready for meal two add olive oil, sliced tomatoes, and the juice of one lime. Season with garlic salt, seasoned salt, and fresh ground pepper. Toss and enjoy an exceptional pasta salad.

Grammie's Chicken

This is my family's all-time favorite chicken dish. Sue Lombardi gave me this recipe when we were both young brides. By rights, the name should belong to Sue, but Natalie, Jeffrey, and Jamari always ask for Grammie's Chicken every time we get together. Lately I've taken a batch with us when we travel to see the grandchildren because it freezes so well, and it leaves me more time to spoil them.

> 18 large chicken legs and thighs
> Flour
> Seasoned salt
> Garlic salt
> Generous amount of fresh ground pepper
> 1 cube butter

Preheat oven to 400 degrees.
Wash the chicken and set on a paper towel to dry.
Melt butter in a large roast pan.
Put flour in a paper bag and add half the chicken pieces.
Shake until well coated.
Do the same with the rest of the chicken.
Spread the chicken in the pan.
Season lightly with salts and pepper.
Cook in the oven for 30 minutes.
Turn chicken and season lightly with salts and pepper.
Cook for another 30 minutes.
Drain chicken on a paper towel.

Menu Suggestions
Lime Vinaigrette Salad
Mashed potatoes and gravy, or noodles
Carrots or broccoli
Ice cream sundaes

Olga's Chicken Veneto

I feel privileged to have eaten this succulent chicken and been given this recipe by Olga Giovanacci from Mom's Italian Village. All of the food at Mom's was authentic Italian food, and the robust aroma of the food permeated the restaurant. You knew that the food had been cooked with love and care all day long. It was a sorry time for Santa Barbara when Mom's stopped serving the best Italian food in this city and closed their doors.

Pete and I decided to give a "mystery party" at Mom's and called it the Chicago Caper. Olga spent time going over my costume, making sure I had a 20s headband and boa. She was as excited about the party as Pete and I were. It was a dark and rainy night, and when all of the mobsters came into the restaurant, the maitre d' had been given "instructions from the boss to leave our pieces at the door." (Olga's idea.)

> 2 chicken halves—1 per person
> Chopped garlic
> Rosemary, fresh
> Oil (olive oil of your choice)
> Salt and pepper

Preheat oven to 375 degrees.
Place chicken skin side down on lightly oiled pan.
In the chicken cavity add chopped garlic, sprigs of rosemary, salt and pepper.
Pour small amount of olive oil into cavity.
Bake until brown, about 30 minutes.
Turn and bake until brown, about 30 minutes more.

"Bake approximately 1 hour—it could be less. We had more to bake, so it took longer. The amount of garlic or rosemary is really up to you—if you like lots of garlic, 3–4 large cloves should do it. Rosemary, again, is to your taste—we actually never measured. It was always an eye measurement for the rosemary, and for salt and pepper it was either an eye measurement or a sprinkle of the hand measurement. Now you know why I can't figure out how to put all this down in a recipe book. Enjoy! Let me know. Good luck."

—Olga Giovanacci

Perfect Prime Rib

1 4–6 pound standing rib roast
6 cloves garlic, cut in slivers
2 10½-ounce cans beef consommé (undiluted)
Seasoned salt, garlic salt
Fresh ground pepper
1 small jar spiced apple rings or spiced crab apples
Parsley

Preheat oven to 400 degrees.
Rinse off roast, wipe dry and set in a large roaster, fat side up.
Rub roast with a few garlic slivers.
Cut slits in the roast and insert garlic cloves. This is called lacing.
Season roast heavily with salts and pepper.
Cook for 20 minutes.
Reduce heat to 350 degrees.
Add 1 can consommé. Add the second can throughout the
cooking, basting each time. Cook for 20 minutes per pound or
longer, depending on the degree of rareness you want. Twenty
minutes per pound will be medium rare with two medium end cuts.
Slice and put on a platter garnished with parsley and apple rings
or crab apples.

Betsy's Beef Stroganoff

1½ pounds fillet or sirloin, sliced about ½ inch thick,
 dredged in flour, salt, and pepper
1 clove garlic, minced, or a sprinkle of garlic powder
1 medium onion, chopped fine
3 tablespoons butter
½ pound mushrooms, sliced
8–10 ounces beef bouillon
2 tablespoons flour
1 cup sour cream

In a small frying pan, sauté the mushrooms in 1 tablespoon butter and set aside.

In a medium frying pan, brown the beef, garlic, and onion in 2 tablespoons butter.

Remove the mixture from the pan and set aside.

Add the flour, starting with 2 tablespoons, to the drippings in the pan and blend for 3 minutes over medium-low heat.

Add the bouillon, stir, and cook until the sauce begins to thicken, about 5 minutes.

If the sauce seems too thin, mix 1 tablespoon flour with water to form a paste and add to the sauce, stirring and cooking for several minutes.

Add the sour cream and blend well.

Add the meat mixture and the mushrooms and cook 5–10 minutes.

Menu Suggestions
Simple Green Salad
Noodles
Green beans
Lime Custard
Hearty Burgundy

Bertha's Sauerbraten

This is a special, sentimental dish that Pete's mother, Bertha, used to make and passed down to Pete. We serve it during the holidays for a contrast in tastes to holiday sweets. During winter months, it's a hearty, stick-to-the-ribs meal. I like to use blue-and-white dishes and geraniums as a centerpiece to give a festive European flair. Prosit!

> 2–2½ pound beef roast—shoulder clod works well
> If you use a 4–5 pound roast, double all ingredients
> except the onion
> 1 cup red wine vinegar
> 1 cup water
> ½ teaspoon pepper
> 4 bay leaves
> ½ tablespoon dry mustard
> 2 tablespoons salt
> 2 tablespoons sugar
> 2 cloves
> 1 large onion, sliced

Marinate the meat in a mixture of the other ingredients 48–72 hours, turning morning and night.

When ready to cook, flour and brown the roast in a deep casserole.

Remove bay leaves and cloves from the marinade.

Add the liquid to the pot.

Cover, and simmer over medium-low heat until tender to the fork—approximately 2 hours.

When the roast is done, remove from the pot and make gravy from the liquid using Method 2 on page 186.

Menu Suggestions
Butter Lettuce Salad
Mashed potatoes and gravy
Red cabbage
Rye and/or dark pumpernickel bread and butter
Baked apple

Big Dave's Italian Beef

This is a favorite in Chicago, much like the all-American hot dog. Almost every Chicago native I've ever known has a recipe for Italian Beef. Pete and I found Big Dave's in Chicago and went in to try the famous sandwiches. Big Dave was actually sitting in his restaurant having lunch and gave us this recipe. Thank you, Big Dave!

6 pounds beef knuckle, top round or inside round
6 green bell peppers
Water
Salt and pepper
6 cloves garlic, chopped
1 cup olive oil
Sugar
Large rolls

Preheat oven to 500 degrees.
Wash and dry beef and season heavily with salt and pepper.
Put beef in a large roasting pan and cover with water.
Cook in preheated oven for 1 hour.
Reduce heat to 350 degrees and cook 4 hours more.
Refrigerate meat in juice overnight.
Next day, remove meat from pan, and scoop off any solidified fat.
Thinly slice beef. If you don't have a slicer, take the beef to your butcher and have him slice it.
Warm juice, taste, and season to taste.
Wash bell pepper, pat dry, and slice into thin slices.
In a small casserole, layer bell pepper, garlic, and sprinkle with sugar.
Pour olive oil over the peppers, garlic and sugar.
Bake in oven for 20–25 minutes at 350 degrees or until peppers are soft.
When ready to serve, boil juice and soak meat in it.
Slice large rolls and put meat with juices on the roll and cover with sweet peppers.

A great Super Bowl dish!

Old Fashioned Meat Loaf

The first meat loaf I made as a twenty-year-old bride was the ugliest, worst stuff I ever tasted. I had found the recipe in the food section of the paper and was determined to try something new. Imagine oatmeal, tomato sauce, no seasoning except tarragon—ugh! This meat loaf, however, is excellent, and freezes well. Sometimes I make two or three loaves and give some to family or friends.

> 1 pound ground chuck
> ½ pound ground veal
> ½ pound ground pork
> 2 cups Italian seasoned bread crumbs
> ½ teaspoon each celery salt, black pepper, seasoned
> salt, garlic salt
> Dash regular salt
> 1 tablespoon dry mustard
> 1½ cups milk
> 2 eggs, beaten
> 2 tablespoons Worcestershire sauce
> ¼ cup soy sauce
> 1 cup ketchup (enough to cover meat loaf)

Preheat oven to 350 degrees.
Put all the dry ingredients in a large mixing bowl.
Mix together well.
Add the milk and eggs to dry mixture.
Mix the chuck, pork, veal, and Worcestershire sauce with the dry ingredients and work well, almost like kneading bread.
Shape well-mixed ingredients into a loaf.
Pour soy sauce and milk over the loaf.
Spread a thick layer of Ketchup over the meat loaf.
Bake for 1½ hours.

Menu Suggestions
Lime Vinaigrette Salad
Baked potato or garlic mashed potatoes
Broccoli or snap beans

Mayme Valentine's Leg of Lamb

Leg of lamb, 4–6 pounds
Cracker or bread crumbs
1 medium onion
Salt and pepper to taste

Wipe off the lamb with a damp cloth. Salt and pepper to taste.
Sprinkle top side with cracker or bread crumbs.
Cut onion into 6 slices to place under lamb as it roasts.
Place lamb in 450-degree oven in a shallow, uncovered pan.
After 15 minutes reduce heat to 350 degrees for 2½–3½ hours.
Serve with mint jelly.

Roasted Lamb Shanks

4 lamb shanks, cracked
1 onion, thinly sliced
4 cloves of garlic, chopped
Garlic salt, seasoned salt, fresh ground pepper to taste

Preheat oven to 400 degrees.
Place onion on the bottom of roasting pan.
Wash and dry lamb shanks and season.
Place chopped garlic on each lamb shank.
Put enough water in roaster to come halfway up shanks.
Cook for ½ hour.
Reduce heat to 350 degrees and cook for 2½ hours more.
Baste once or twice during cooking.
Cover with foil until ready to serve.

You can also barbecue lamb shanks. On a Weber barbecue, lay lamb on grill and cook using the indirect method for 1 hour and 45 minutes.
Internal temperature should read 150 degrees with meat thermometer.

Menu Suggestions
Butter lettuce salad
Mashed potatoes and gravy
Fresh carrots
Small Portobello mushrooms

Eleanor's Pasta e Fasoi (Fagioli)

This Venetian dish was a favorite at the Andruizzos' house in Burbank. On Friday nights calamari was substituted for the sausage and ham to honor the Catholic Church's tradition of a meatless Friday. This is now a favorite at La Collina Verde, and Emily and Inga (Pete's daughters) like it so much they used to eat it for breakfast. It is especially welcome in cold weather because it's such a hearty dish. It freezes well and is great to take camping or skiing. Over the years my version of this recipe has become more like a stew than Eleanor's soup.

3 quarts water
1 pound red beans
3 tablespoons plus 1 teaspoon olive oil
4 cloves garlic, chopped
2 large onions, chopped
6 ham hocks, cracked
6 Italian sausages
2 stalks celery, chopped fine
2 carrots, peeled and chopped fine
1 large tomato, chopped, or 1 cup tomato sauce
½ teaspoon salt and pepper
2 beef bouillon cubes
½ cup fresh parsley, chopped
3 large fresh basil leaves, chopped, or ½ teaspoon dry
1 16-ounce box fusilli
Parmesan cheese, grated

Wash beans and soak in cold water overnight, or use the quick-soak method (see package for direction).

In a large soup pot, sauté onion and garlic in 1 tablespoon plus 1 teaspoon olive oil.

Add the beans, celery, carrots, tomato, bouillon cubes, salt and pepper.

Bring to a boil and skim the froth from the broth.

Reduce the heat to medium-low and simmer for 30 minutes.

Sauté Italian sausage, drain on paper towel, and slice.

Add sausage and ham hocks to the pot.

Cook for about 2 hours, or until the beans are tender.

Remove half the beans, mash, and return to the pot.

Bring to a boil, add pasta, 2 tablespoons olive oil, basil, and parsley.

Cook until the pasta is al dente.

Serve in large serving bowls with a generous amount of Parmesan cheese grated over the top.

Depending on your guests, you can serve a ham bone in the serving bowl or remove the meat from the bone and discard the bones.

Menu Suggestions
Lime Vinaigrette Salad
Chianti

Mrs. Dionne's Gingersnaps

Mrs. Dionne was the epitome of "everyone's grandmother." When she came to baby-sit my daughter, Jennifer, she brought gingersnaps, books, games, and sometimes her own granddaughter, Paris, who was the same age as Jennifer. She would plan outings and activities for the girls and loved her "adopted grandchildren" as her own. Sometimes I think it's hard when families are scattered because they don't have grandparents close by to provide the comforting touch a grandmother can provide. Maybe there should be an Adopt-a-Grandmother Association?

 ¾ cup shortening and margarine, mixed
 1 cup white sugar
 1 egg, beaten
 ¼ cup green label Brer Rabbit molasses

Mix ingredients in a large bowl.
Add:

 2 cups flour
 1 teaspoon cinnamon
 1 teaspoon ginger
 1 teaspoon cloves
 2 teaspoons baking soda
 ½–1 teaspoon salt

Cool in refrigerator a short while.
Preheat oven 350 degrees.
Roll teaspoonfuls of dough in sugar and put on cookie sheet.
Bake for 8–10 minutes.

Inga and Emily's Dutch Baby Shoes

When Pete's daughters, Inga and Emily, were preteens, their "speciality of the house" was cookies. They would get in the kitchen and giggle and bake up huge batches of cookies. Although these are not really cookies, they are sweet when dusted with powdered sugar. The girls especially liked them for breakfast on special occasions.

½ cup butter, melted
6 eggs
1½ cups milk
1½ cups flour
Powdered sugar

Preheat oven to 425 degrees.
Pour butter into a 4½–5 quart baking pan.
Put eggs in a blender or food processor and blend on high for 1 minute.
Gradually add the milk and then slowly add flour while the mix continues blending.
Blend for 30 seconds more.
Pour into the pan and bake for 20–25 minutes.
Cool and cut into squares or bars.
Dust with powdered sugar.

Ganny's Custard

This recipe is my grandmother's (Ganny) and was given to me by my Aunt Sharon. To this day, like Aunt Sharon, I make my custard in the same bowl in which Ganny brought custard to me—everybody knew it as a jewel tea bowl. Ganny was an angel grandmother, who knew how to comfort you when you were not well, always made room for one more, and always had love, joy, and time to care with great kindness.

4 eggs, beaten
1 cup sugar
1 teaspoon vanilla
½ teaspoon salt
1 quart milk, scalded

Preheat oven to 350 degrees.
Mix first four ingredients in a baking dish.
Scald milk and add it to the baking dish, mixing well.
Set the dish in a baking pan with about 1½–2 inches of water.
Bake for 1 hour or until a knife inserted in the middle comes out clean.

Barbara's Pretzel Salad

This is a very delicious salad, really a dessert. Barbara is always asked to bring this to family reunions.

2 cups crushed pretzels (not too fine)
¾ cup melted butter
3 tablespoons sugar
8 ounces cream cheese, softened
1 cup sugar (I use less)
8 ounces Cool Whip
1 package strawberry Jell-O
2 10-ounce packages frozen strawberries

Preheat oven to 400 degrees.

Mix the crushed pretzels, sugar, and melted butter and spread in a 9" x 13" pan.

Bake for 8–10 minutes.

Cool completely. This is very important.

Whip the cream cheese until smooth.

Add sugar and blend well.

Stir in Cool Whip.

Spread over the pretzel mixture, being sure to cover the edges of the pan.

Refrigerate for about an hour, or until set.

Dissolve Jell-O in 2 cups boiling water.

Add frozen strawberries and stir until they separate.

Pour over the cream cheese layer and chill until set.

Cathy's Christmas Rum Balls

Cathy is an "old" and dear friend from junior high school days in beautiful downtown Burbank. We were neighbors and walked to school together and laughed all the way to school. Cathy brought her wonderful sense of humor along with this gift of rum balls one Christmas and shared them with the family. They are wonderful.

1 cup finely crushed vanilla wafer crumbs
1 cup confectioner's sugar
½ cup finely chopped walnuts
1½ teaspoons cocoa
½ cup rum, brandy, or bourbon
1 tablespoon clear corn syrup
Powdered sugar

In a bowl, mix wafer crumbs, sugar, nuts, and cocoa.
Add liquor and corn syrup and mix well.
Roll into ¾" balls and roll in powdered sugar.
Layer on waxed paper and store in tightly covered containers.
No refrigeration or baking needed.

I usually double the recipe and add enough liquor to achieve the moistness I want.

Mrs. Johnson's Fruit Cake

Pete used to run the early-morning milk route with Mr. Johnson in Chicago. After the morning deliveries, Mrs. Johnson would serve lunch with this delicious fruitcake for dessert.

½ pound butter
⅔ cup brown sugar
⅔ cup white sugar
6 eggs
1½ cups flour
1 teaspoon salt
1 pound glace cherries, whole
½ pound pecans
¼ pound walnuts
2 red and 2 green glace pineapple slices, chopped
1 package dates, cut up
4 tablespoons brandy or whiskey

Preheat oven to 325 degrees.
Mix all ingredients.
Line an angel food cake pan with brown or waxed paper—do not grease.
Bake for 1½ hours.
Wrap in wax paper after cooling completely.
Slice thin.

Blueberry Buckle

Blueberry Buckle is a favorite of La Collina Verde for Thanksgiving and Christmas breakfast. Served with fruit and juice, this will tide you over till the holiday feast.

For the batter:
 ½ cup shortening
 ½ cup sugar
 1 egg, beaten
 2 cups flour
 ½ teaspoon salt
 2½ teaspoons baking powder
 ½ cup milk

Preheat oven to 350 degrees.
In a mixing bowl, thoroughly cream shortening and sugar.
Add egg and mix well.
Sift dry ingredients together.
Add dry ingredients to creamed mixture, alternating with the milk.
Pour into 2 greased and floured 8" cake pans.

For the topping:
 7 cups blueberries, fresh or frozen
 ½ cup sugar
 ½ cup flour
 ½ teaspoon cinnamon
 ¼ cup butter

In a mixing bowl, combine the sugar, flour, cinnamon, and cut in the butter until the mixture is crumbly.
Put the blueberries over the batter.
Sprinkle the topping over the blueberries.
Bake for 1 hour.

Index

Amy's Mai Tai, 35
Andy's Ceviche, 95
Appetizers
 Artichoke Tapenade, 41
 Artichokes with Lime and Soy
 Mayonnaise, 81
 Crab Dip, 43
 Guacamole, 46
 Herb and Lime Cheese Ball, 42
 Laurie's Salsa, 47
 Lime and Herb Oysters, 45
 Merle's Roasted Garlic Appetizer,
 173
 Oven-Fried Chicken Drumettes, 49
 Sautéed Bay Scallops with Lime and
 Herbs, 44
 Shrimp Cocktail, 44
 Summer Bruchetta, 48
Artichoke
 Artichoke Tapenade, 41
 Jennifer's Chicken with Artichokes,
 113
Aunt Sharon's Copper Pennies, 179
Aunt Sharon's Sherbet Cake, 168
Avocado
 Guacamole, 46
 Laurie's Salsa, 47
 Papaya Salsa, 148

Baby Back Ribs with Lime Zest
 Barbecue Sauce, 134
Bachelor Cooking, 19
Baked Zucchini, 84
Barbara's Pretzel Salad, 202
Basil and Tomato Salad, 68
Battling Bobbie's Garlic Beans, 86
Beans
 Battling Bobbie's Garlic Beans, 86
 Eleanor's Pasta e Fasoi (Fagioli), 197
 Helen's Pink Beans, 180
 Laurie's Salsa, 47

Turkey-Bean Minestrone Soup, 60
Beef
 Bertha's Sauerbraten, 192
 Betsy's Beef Stroganoff, 191
 Big Dave's Italian Beef, 193
 Louie's Short Ribs, 128
 Old Fashioned Meat Loaf, 194
 Perfect Prime Rib, 190
 Poor Man's Prime Rib, 127
 Slavonic Steak, 126
 Steak La Collina Verde, 125
Beer Mary, 32
Bertha's German Potato Salad, 176
Bertha's Sauerbraten, 192
Bertha's Sweet and Sour String Beans,
 178
Bertha's Turkey Dressing, 184
Betsy's Beef Stroganoff, 191
Betty Jo's Potato Salad, 177
Big Dave's Italian Beef, 193
Bloody Mary, 31
Blueberry Buckle, 205
Bornhoeft's Flying Salmon, 109
Butter Lettuce Salad with Herbs and
 Watercress, 69

Cakes
 Lime Flower Cake, 159
 Aunt Sharon's Sherbet Cake, 168
Carrot
 Aunt Sharon's Copper Pennies, 179
 Cream of Carrot Soup, 55
 Fresh Veggie Salad, 76
Carlton's Gourmet Lamb Chops, 129
Carlton's Honey Balsamic Vinaigrette,
 144
Caryl's Red Potato Bake, 181
Cathy's Christmas Rum Balls, 203
Cheese
 Crab Dip, 43
 Herb and Lime Cheese Ball, 42

Jan's Cheese-Stuffed Zucchini, 85
La Collina Verde Pasta Salad, 73
Summer Bruchetta, 48
Cheri Hollywood's Cioppino, 99
Cheri's Terrific Lime Cheesecake, 164
Chicken
 Chicken Soup, 58
 Diane Brush's Lime-Grilled
 Chicken, 114
 Ginger's Teriyaki Chicken, 115
 Grammie's Chicken, 188
 Jennifer's Chicken with Artichokes,
 113
 Jerry's Chicken and Olives, 117
 Lime Herb Chicken, 118
 Lime Soup, 59
 Limelite Chicken, 116
 Olga's Chicken Veneto, 189
 Oven-Fried Chicken Drumettes, 49
 Quail or Chicken Marinade, 142
 Roast Chicken, 119
Chocolate
 Gourmet Chocolate Sauce, 156
Cilantro Butter, 150
Cookies
 Lime Shortbread Cookies, 165
 Mrs. Dionne's Gingersnaps, 199
Cool Breeze, 31
Cornish Game Hens, 120
Corona and Lime, 33
Crab Dip, 43
Cream of Carrot Soup, 55
Cream of Mushroom Soup, 174
Creative Leftovers, 18
Cubra Libre, 31

Desserts (see also cakes, cookies, and
 pies)
 Blueberry Buckle, 205
 Cathy's Christmas Rum Balls, 203
 Cheri's Terrific Lime Cheesecake,
 164
 Ganny's Custard, 201
 Inga and Emily's Dutch Baby
 Shoes, 200

Mrs. Johnson's Fruit Cake, 204
Summer Peach Cobbler, 166
Diane Brush's Lime-Grilled Chicken,
 114
Dressing
 Carlton's Honey Balsamic
 Vinaigrette, 144
 George's Caesar Salad, 70
 Light Vinaigrette, 144
 Lime Vinaigrette Dressing, 143
 Mustard Vinaigrette, 145

Eggs
 Ginger and Lime Crème Brulée,
 157
 Lime Baked Custard, 158
 Lime Hollandaise Sauce, 145
Eleanor's Pasta e Fasoi (Fagioli), 197
Elephant Stew, 135

Fettuccine, 185
Fish
 Andy's Ceviche, 95
 Bornhoeft's Flying Salmon, 109
 Cheri Hollywood's Cioppino, 99
 Fish Soup with Fennel, Leeks, and
 Lime, 57
 Fresh Idaho Trout, 101
 Lime Snapper Veracruz, 104
 Limed Hawaiian Escolar, 105
 Oven-Fried Halibut with Lime
 Cilantro Butter, 106
 Pete's Squid, 187
 Salmon La Collina Verde, 107
 Sea Bass with Lime-Fruit Compote,
 103
 Uncle Tom's Heavenly Halibut, 102
Fresh Idaho Trout, 101
Fresh Veggie Salad, 76
Fruit and Butter Lettuce Salad, 66

Ganny's Custard, 201
Garlic
 Battling Bobbie's Garlic Beans, 86
 Lime and Garlic Sautéed Chard, 82

Merle's Roasted Garlic Appetizer, 173
George's Caesar Salad, 70
Ginger and Lime Crème Brulée, 157
Ginger's Teriyaki Chicken, 115
Ginger's Teriyaki Marinade, 142
Ginger's Vegetable Toss, 74
Gourmet Chocolate Sauce, 156
Grammie's Chicken, 188
Gravy, 186
Green beans
 Bertha's Sweet and Sour String Beans, 178
Guacamole, 46

Hawaiian Pork Chops, 131
Helen's Pink Beans, 180
Herb and Lime Cheese Ball, 42
History of the Lime, 16
Honey Lime Butter, 150

Inga and Emily's Dutch Baby Shoes, 200
Irmal's Salsa Fresca, 149
Island Breeze, 30

Jan's Cheese-Stuffed Zucchini, 85
Jennifer's Chicken with Artichokes, 113
Jerry's Chicken and Olives, 117

Kai Poroche, 34
Kate's Raspberry Lime Pie, 160

LCV Vodka Cocktail, 29
La Collina Verde Martini, 29
La Collina Verde Pasta Salad, 73
La Collina Verde Sauce, 146
Lamb
 Carlton's Gourmet Lamb Chops, 129
 Mayme Valentine's Leg of Lamb, 195
 Roast Lamb with Lime and Mint Jelly, 130

Roasted Lamb Shanks, 196
Laurie's Salsa, 47
Leeks
 Fish Soup with Fennel, Leeks, and Lime, 57
 Marian's Leek and Potato Soup, 56
Light Vinaigrette, 144
Liliane's Lime Chantilly Pie, 162
Lime and Garlic Sautéed Chard, 82
Lime and Herb Oysters, 45
Lime Baked Custard, 158
Lime Butter, 150
Lime Flower Cake, 159
Lime Granita, 155
Lime Herb Chicken, 118
Lime Hollandaise Sauce, 145
Lime Marinade, 141
Lime Scampi with Angel Hair Pasta, 98
Lime Shortbread Cookies, 165
Lime Snapper Veracruz, 104
Lime Soup, 59
Lime Vinaigrette Dressing, 143
Lime Vinaigrette Salad, 65
Lime Zest Barbecue Sauce, 147
Limebrights, 23
Limed Hawaiian Escolar, 105
Limelights, 22
Limelite Chicken, 116
Louie's Short Ribs, 128

Margaritas, 34
Marian and Mike's Margaritas, 35
Marian's Leek and Potato Soup, 56
Marinades
 Bertha's Sauerbraten, 192
 Carlton's Gourmet Lamb Chops, 129
 Diane Brush's Lime-Grilled Chicken, 114
 Ginger's Teriyaki Chicken, 115
 Ginger's Teriyaki Marinade, 142
 Limelite Chicken, 116
 Lime Herb Chicken, 118
 Lime Marinade, 141

Quail or Chicken Marinade, 142
Slavonic Steak, 126
Uncle Tom's Heavenly Halibut, 102
Mayme Valentine's Leg of Lamb, 195
Merle's Roasted Garlic Appetizer, 173
Mrs. Dionne's Gingersnaps, 199
Mrs. Johnson's Fruit Cake, 204
Mushrooms
 Cream of Mushroom Soup, 174
 La Collina Verde Sauce, 146
 Spinach Salad with Mustard
 Vinaigrette, 72
 Steak La Collina Verde, 125
Mustard Vinaigrette, 145

Nopales, 83

Old Fashioned Meat Loaf, 194
Olga's Chicken Veneto, 189
Orchard Cooler, 30
Oven-Fried Chicken Drumettes, 49
Oven-Fried Halibut with Lime
 Cilantro Butter, 106

Papaya Salsa, 148
Pasta
 Eleanor's Pasta e Fasoi (Fagioli), 197
 Fettuccine, 185
 La Collina Verde Pasta Salad, 73
 Lime Scampi with Angel Hair
 Pasta, 98
The Peg, 30
Perfect Prime Rib, 190
Pete's Squid, 187
Pico de Gallo, 149
Pies
 Kate's Raspberry Lime Pie, 160
 Liliane's Lime Chantilly Pie, 162
 Santa Barbara Lime Pie, 163
Pimm's Cup, 32
Poor Man's Prime Rib, 127
Pork
 Baby Back Ribs with Lime Zest
 Barbecue Sauce, 134
 Eleanor's Pasta e Fasoi (Fagioli), 197

Hawaiian Pork Chops, 131
Old Fashioned Meat Loaf, 194
Sauerkraut and Spareribs, 132
Potatoes
 Bertha's German Potato Salad, 176
 Betty Jo's Potato Salad, 177
 Caryl's Red Potato Bake, 181
 Marian's Leek and Potato Soup, 56
 Scalloped Potatoes, 183
 Stuffed Baked Potatoes, 182

Quail or Chicken Marinade, 142

Roast Chicken, 119
Roast Duck, 121
Roast Lamb with Lime and Mint
 Jelly, 130
Roasted Lamb Shanks, 196

Salad
 Barbara's Pretzel Salad, 202
 Basil and Tomato Salad, 68
 Bertha's German Potato Salad, 176
 Betty Jo's Potato Salad, 177
 Butter Lettuce Salad with Herbs
 and Watercress, 69
 Fresh Veggie Salad, 76
 Fruit and Butter Lettuce Salad, 66
 George's Caesar Salad, 70
 Ginger's Vegetable Toss, 74
 La Collina Verde Pasta Salad, 73
 Lime Vinaigrette Salad, 65
 Santa Barbara Fruit Salad, 75
 Simple Green Salad, 67
 Spinach Salad with Mustard
 Vinaigrette, 72
Salmon La Collina Verde, 107
Salsa
 Irmal's Salsa Fresca, 149
 Laurie's Salsa, 47
 Papaya Salsa, 148
 Pico de Gallo, 149
 Sheri's Quick Hot Salsa Verde, 148
Sangria by Sue, 36
Santa Barbara Fruit Salad, 75

Santa Barbara Lime Pie, 163
Sauces
 Gourmet Chocolate Sauce, 156
 La Collina Verde Sauce, 146
 Lime Hollandaise Sauce, 145
 Lime Zest Barbecue Sauce, 147
Sauerkraut and Spareribs, 132
Sautéed Bay Scallops with Lime and
 Herbs, 44
Scalloped Potatoes, 183
Scotch Cocktail, 29
Scotty's Shrimp, 97
Sea Bass with Lime-Fruit Compote,
 103
Sharon's Peel-and-Eat Shrimp, 96
Shellfish
 Cheri Hollywood's Cioppino, 99
 Crab Dip, 43
 Lime and Herb Oysters, 45
 Lime Scampi with Angel Hair
 Pasta, 98
 Sautéed Bay Scallops with Lime and
 Herbs, 44
 Scotty's Shrimp, 97
 Sharon's Peel-and-Eat Shrimp, 96
 Shrimp Cocktail, 44
Sheri's Quick Hot Salsa Verde, 148
Sheri's Vegetable Soup, 175
Shrimp Cocktail, 44
Simple Green Salad, 67
Slavonic Steak, 126
Soup
 Chicken Soup, 58
 Cream of Carrot Soup, 55
 Cream of Mushroom Soup, 174
 Fish Soup with Fennel, Leeks, and
 Lime, 57
 Lime Soup, 59
 Marian's Leek and Potato Soup, 56
 Sheri's Vegetable Soup, 175
 Turkey-Bean Minestrone Soup, 60
Sparkling Limeade Mist, 33
Spinach Salad with Mustard
 Vinaigrette, 72
Steak La Collina Verde, 125

Stuffed Baked Potatoes, 182
Summer Bruchetta, 48
Summer Peach Cobbler, 166
Sweet Vermouth Cocktail, 29

Tecate and Lime, 33
Tomato
 Basil and Tomato Salad, 68
 Irmal's Salsa Fresca, 149
 Pico de Gallo, 149
 Summer Bruchetta, 48
Turkey
 Turkey-Bean Minestrone Soup, 60

Uncle Tom's Heavenly Halibut, 102

Zucchini
 Baked Zucchini, 84
 Fresh Veggie Salad, 76
 Jan's Cheese-Stuffed Zucchini, 85

NOTES

NOTES

NOTES